Graffiti School

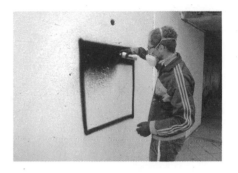

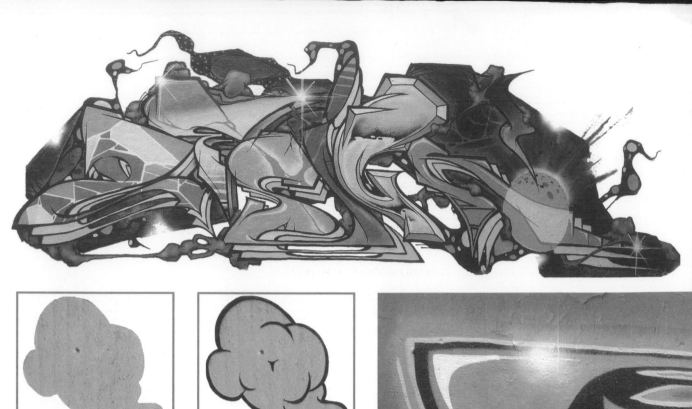

Chris Ganter

Graffiti School

A Student Guide
with Teacher's Manual

over 300 illustrations, 101 in color

 Thames & Hudson

Clockwise from top left: details from
'Style' (page 133); 'Size' (pages 16–17);
'Quality' (page 15); and 'Triangle' (page 152).

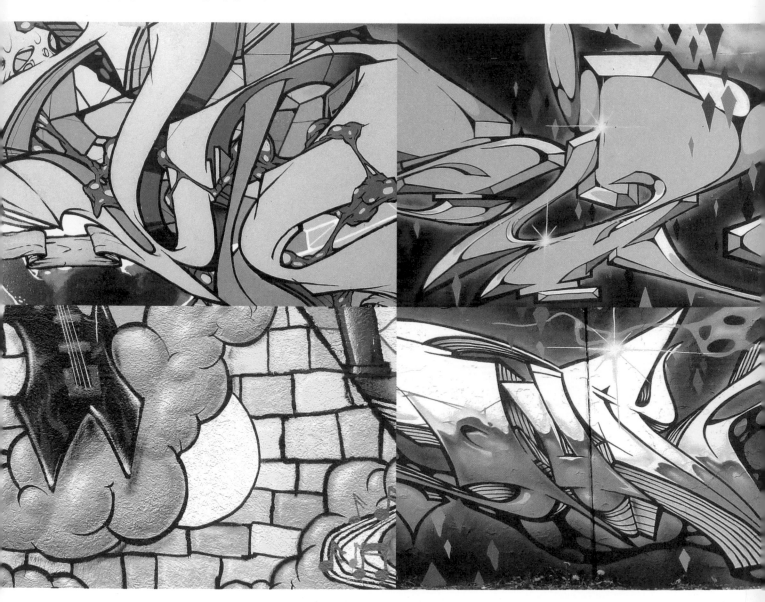

Graffiti School © 2013 Christoph Ganter

Designed by Christopher Perkins

First published in 2013 in paperback
in the United States of America by
Thames & Hudson Inc., 500 Fifth Avenue,
New York, New York 10110

thamesandhudsonusa.com

Reprinted 2016

Library of Congress Catalog Card Number
2012956283

ISBN 978-0-500-29097-2

Printed and bound in China
through Asia Pacific Offset Ltd

Contents

Introduction
Getting up

Graffiti writing, the art of creating beautiful lettering, is not solely about skill. Someone who is technically talented at drawing graffiti isn't necessarily a successful graffiti writer in practice because becoming a legendary writer also takes proactivity – getting out and 'getting up' on a wall. Sketching at home is unlikely to bring you fame and a reputation. The real achievements of graffiti writers are the lengths to which they go to realize pieces; to practise and improve their skills; to develop their own style after years of training; to travel around, find locations and organize paint; to keep their name up despite the trouble and inconvenience. It's a challenging and demanding hobby, but dedication like this is what brings success.

Graffiti School – the first extensive manual of its kind – is designed to introduce students to the world of graffiti writing and provide an overview of the art's techniques, styles and possibilities. It's no replacement for spending

'Quality'

time putting paint on walls, also (though I try to be as comprehensive and objective as possible) the illustrations do reflect my own individual taste and perception of style. However, coupling the skills and information explained in *Graffiti School* with commitment and originality is a superb place to start. Trying over and over again without giving up will not only win you respect, but will also help you discover your own unique style.

Graffiti today is at a crossroads. Many people would agree that the hobby can be tolerated, indeed, can potentially be seen as art, so long as no laws are broken in the process of its creation. The graffiti scene itself is split into two groups, each with a different appreciation of the art: illegal sprayers focus on the location, action and difficulty of executing a piece, while legal sprayers judge work based on the artistic quality of the finished article. Needless to say, this book is designed to be of use to the second group, for whom the aesthetics of complex letters and the design of complex lettering are paramount. Better results will always be easier to achieve when conditions are favourable and less pressured.

One problem encountered by younger sprayers is the lack of the experience and ideas needed to create the detailed pieces commonly found on legal walls. Because of this they often turn to illegal spots with reduced 'quality control'. One of the purposes of this book is to help inexperienced sprayers get more elaborate results by directing their attention to the aesthetic side of graffiti. Skilful pieces (as opposed to uninspired or rushed work) are more readily enjoyed and appreciated, and with the help of this book I hope budding sprayers can get impressive results that conform to the ideas of art held by graffiti writers and society.

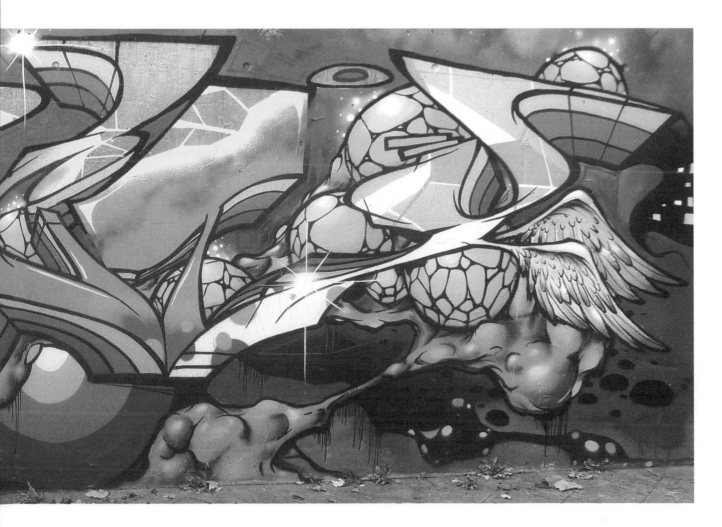

[1] Background

People who do not actively write graffiti tend to know very little about it. From graffiti terminology to the ability to read graffiti letters, and from recognizing innovative and individual ideas to judging the quality of a style – the majority of society has no idea. Many accept it as a phenomenon of (especially Western) civilization but are uninterested in its roots or artistic quality. This ignorance, together with the illegality that is still connected with some forms of graffiti, shrouds it in a sense of mystery, as if graffiti were some secret art for insiders only. For sprayers, such background knowledge is essential in order to understand the concepts of graffiti culture and meet with the accepted standards of graffiti style. For this reason, this first chapter covers the most important information regarding the historical, societal, cultural and legal aspects of graffiti.

Only by viewing graffiti within its context can it be understood for what it truthfully is: an expression of the human desire to create something lasting that will be noticed, and hopefully admired, by others.

Graffiti and society

Graffiti comes in a wide variety of forms and disciplines, from seemingly amateurish scribbles to masterfully executed murals that dominate walls. It can look both decorative and aesthetically attractive; however, the truth is that the quality of many graffiti pieces in public spaces is far from pleasing to the eye. Not all sprayers act out of artistic or creative motivation, wanting to beautify their environment. And it's easily forgotten that many different people, all with different motives, messages and priorities, use public space.

Due to these variations in quality, the public's perception of graffiti ranges from art to vandalism. It is also a constant source of discussion in the media; on one side of the argument are the (rightly) angry property owners, who think of uninvited graffiti as criminal damage lacking artistic ambition, while on the other side are the appreciative supporters who have come to view graffiti as a skill and an art. When carried out on legal walls (which allow the time needed to create something colourful and clean) graffiti has been increasingly accepted by the public.

Despite (or perhaps even because of) this polarization, graffiti has developed to become unquestionably the most popular youth art form of the last 30 years. No other art movement has changed the face of American and European cities so much as modern graffiti, and its influence on other creative fields – such as advertising or graphic design – is evident. This is unsurprising, as thousands of today's young artists, designers, art directors and architects started their journey into the world of art and graphics as teenagers spraying graffiti. It was as a part of this scene that many of them discovered their love for creative design and began to sharpen their artistic skills.

[**Left**] and [**Above**] Artwork and eyesore.

The question of whether graffiti is art or vandalism is frequently discussed, and the answer to the question is neither particularly hard to deduce nor particularly helpful: it is both! Or more precisely: it *can be* both. A spray can of paint is simply the medium, the tool. How and where it is used lies in the hands of a huge number of individuals – from artists to vandals, and every stage between. Graffiti is therefore far too complex and multilayered to be categorized as just 'art' or just 'vandalism'.

The reality is that graffiti has become an established part of youth culture and will persist into the future. A rising number of city councils have realized that they cannot 'win' the fight against illegal graffiti, and so have decided instead to work together with local graffiti writers. Experience has shown that cooperation and commissioned walls are more cost-effective ways of limiting graffiti than pumping large amounts of money into cleaning the same walls over and over again. As part of such schemes, respected artists are commissioned and given space for expressing themselves with legal designs on frequently tagged walls. The results are complex and colourful murals that are more often than not appreciated by the public and stay untouched for a long time. The sprayer is content with their work, and the council saves the money it would have spent on cleaning – at the same time improving their image by supporting youth art.

Graffiti and the art world

Promoting graffiti as an art form is difficult. Its principle characteristic of occupying public space – often on a large scale and on an immovable surface – makes it hard to exhibit graffiti in galleries. Instead, graffiti is being promoted as urban art, which includes other movements such as street art. Street art also uses public space but works with more figurative elements and other techniques such as stickers, stencils and posters.

Since the turn of the millennium, urban art galleries and art fairs have emerged in larger cities around the globe yet it is mainly figurative works of urban art that are shown and sold there. Classic graffiti pieces are rarely exhibited, as art buyers can find the beauty of modern letter design difficult

to appreciate. The art world tends to see graffiti as the starting point for further artistic development.

Some graffiti artists have developed their work beyond traditional letter design, and have incorporated new influences or adapted special techniques to help their works stand out. Banksy (Britain), Os Gêmeos (Brazil), Daim (Germany) and Shepard Fairey (United States) are all artists with backgrounds in graffiti who have gone on to become world famous – their works now sold in the best galleries and auction houses.

In 2006, Gunter Sachs, a supremely talented art buyer and organizer of Andy Warhol's first European exhibition, invited Swiss graffiti artists Dare and Toast to paint work in an apartment in his legendary castle at Lake Wörth, Austria. This invitation put their writing alongside art by such names as Roy Lichtenstein, René Magritte, Salvador Dalí, Yves Klein and Warhol himself. Apparently Sachs (who died in 2011) saw something in graffiti – perhaps as a serious art form of the day, or maybe as an up-and-coming form for the future. Following this acceptance by such a prominent collector, larger art fairs such as Art Miami, Art Basel or the Documenta in Kassel, Germany, began featuring graffiti artists.

A history of graffiti

In order to appreciate the contemporary culture of graffiti art, it is important to examine its predecessors throughout world history. Understanding graffiti's historical roots and development gives a clearer view of its situation today, and explains some of the new varieties that have emerged. Finding a definition for the term 'graffiti' will be a key part of this chapter, as will an examination of writers' motivations, asking questions such as *Where does graffiti come from? Who did it? Who does it? And why?*

Graffiti forms of the past

Graffiti is by no means a modern invention; rather it is something rooted deeply in the history of mankind. The following pages will explore some of the historical precedents for what we have come to describe as graffiti.

Firstly, the long existence of the term itself is proof that socially unsanctioned writing was occurring in public well before the spray can was invented. The word graffiti (or 'graffito' in the singular) is derived from the Italian *graffiare*, which means 'to scratch' or 'to carve', and the term was popularized by the 1865 book *Graffiti de Pompéi* by Italian archaeologist Raffaele Garrucci. In AD 79, the ancient

Election notice from a wall in Pompeii, *c.* AD 79.

Roman city of Pompeii was buried by ash emitted during an eruption of Mount Vesuvius. Lost for hundreds of years, the city was eventually rediscovered and excavated, and found to be in an excellent state of preservation.

Garrucci examined and recorded the intriguing carvings he found in the antique walls of Pompeii. Here are some translated examples: 'Celadius the Thracian, crush of the girls'; 'Winning is fun'; 'Perarius, you are a thief'; and 'I suffer from a cold'. It seems that people in the remote past felt the need to express themselves just as much as the people of modern civilizations. In fact, the oldest preserved graffito dates back 3,500 years and was carved into a wall in Egypt. It says 'I am very impressed by Pharaoh Djoser's pyramid.'

The Ancient Greek alphabet is considered by many to be the first true alphabet. It contained letters for both vowels and consonants, as well as linking distinct letters with speech sounds, rather than using symbols to represent words. Western alphabets, including Latin, are based on the Greek, and so its evolution can be seen in retrospect as a defining point in the development of modern lettering.

Almost every era has its own characteristically ornate letter style, and we call this art of designing beautiful letters 'calligraphy'. The term is derived from the Greek 'kallos' (beauty) and 'grafein' (to write). Here are some examples of beautiful ancient letter design. The image below shows a handwritten religious text from the Middle Ages. Often the first word of each section of such texts would be decorated with an elaborate initial, and their look resembles modern graffiti in a number of ways. The image below right is an example of printed Gothic text. These printed letters mimic a calligraphic-style script that would have been written using a pen with a broad tip, causing the width of the line to vary as the pen moved in different directions.

Hieroglyphs were small carvings representing either words or parts of words (rather than sounds). Few hieroglyphs would be classed as graffiti, as they were commissioned mostly by the ruling authority.

[**Above**] Gothic title page from Hartmann's *Chronicle of the World*, printed by Anton Koberger in 1493.

[**Left**] Illuminated initial capital 'P' from a thirteenth-century manuscript discussing the psalms and the Epistles of St Paul.

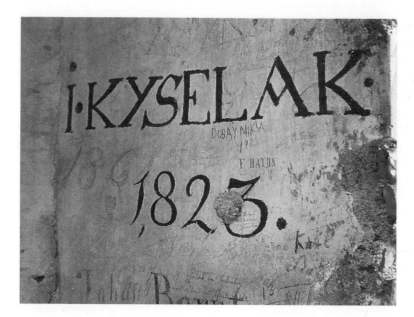

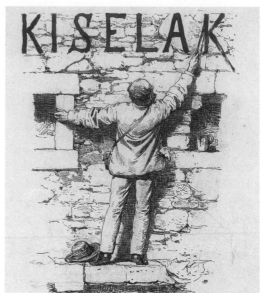

Josef Kyselak's early 'graffiti' and a depiction of him in action.

Designing beautiful letters was common not only in Europe but also in the Far East, where calligraphy had an even higher standing as an independent art form. The Islamic world, too, is known for its artistic, decorative scripts, which were partly a consequence of the Islamic command not to create pictorial representations of living beings. This led instead to a focus on beautifying through abstract decoration and calligraphy.

Throughout history, even though writing finesse was displayed mostly on stretched animal skin or paper, and not on buildings or in public spaces, the visual parallels with modern graffiti remain evident: outlined letters, serifs, bright colouring and illustrations interacting with the letters – these remain the basic elements of modern graffiti art.

The first real graffiti artist to 'tag' (paint his name in multiple public locations) was Josef Kyselak of early nineteenth-century Vienna. Except for the fact that he used a brush and not a spray can to write his name, he meets all the criteria for a tagger. Kyselak travelled around the Austrian Empire, painting his signature – often accompanied by the date – on walls and rocks in order to become famous, or at least notorious.

Some sources claim that a bet triggered his tagging spree; others say it was heartache that made him leave his name wherever he went. Whatever the reason, his craving for recognition reputedly earned him an audience with the emperor, who had him called to the court and advised him to stop the signing. Kyselak had not only written on public walls and rocks but also on chapels and imperial buildings.

With American Edward Seymour's invention of the paint spray can in 1949, new possibilities arose. Pressurized cans were faster and more effective than brushes, and they worked on uneven surfaces. With these advantages, it wasn't long before the first American spray can graffiti emerged. Early tags appeared on trains that rolled through Los Angeles in the 1940s and 50s, but it was only in the 60s that 'Cornbread' from Philadelphia gained a considerable local reputation for tagging. Supposedly he tried to attract a girl's attention by writing his nickname all over her school and along her way home. Later he widened his focus to stations, bridges and buses throughout the city. Even when his plan worked out, Cornbread couldn't stop tagging and they split up after a short time; the girl of his dreams apparently unable to cope with his obsession for leaving his name everywhere.

Gérard Zlotykamien and Harald Nägeli should also be mentioned as pioneers for their use of the spray can in urban centres in 1970s Europe. Their early forms of urban art created simple yet characterful line drawings in public spaces, works that remain influential to modern urban artists such as Stik.

The clear conclusion is that graffiti is no recent phenomenon, but actually part of a timeless human urge to leave something lasting that carries a message to others. Modern graffiti is just another variety of the ancient tradition of an individual communicating through letters written in a public space.

But why has graffiti's appeal grown so widely over the last twenty years? There are two answers to this question. On one hand, growing urbanization in most societies causes an increase in the fear of anonymity and conformity, leading to the desire to reassert a distinct identity and sense of individualism. On the other hand, graffiti as a means of self-expression is nowadays easier and more accessible than ever before. Recent generations have had better, more effective tools for creating graffiti art than any other.

The Hip Hop movement

Hip Hop is probably the biggest youth culture movement of our time. While other subcultures such as Punk or Techno fell into decline after being over-hyped and diluted by mainstream appeal, Hip Hop has proved to be popular and long-lived, yet adaptable enough to renew itself.

Its origins can be found in the major American cities. 1970s New York offered very little room for teenagers to express themselves, and bored youths from poorer areas and different ethnic backgrounds were always looking for ways to apply their creative potential. One outlet was organized parties in streets and public parks, at which DJs played records and MCs rapped to the beat of the set. The teenagers began breakdancing and writing their pseudonyms with permanent markers and spray cans in public spaces. Hip Hop was born.

One of the first and most influential modern graffiti writers was 'TAKI 183', a New York pizza-delivery boy with Greek roots whose tag was a combination of his nickname and the number of the street he lived on. During his trips through the city he would write his tag on doors or bus stops to such an extent that on 21 July 1971 the *New York Times* reported about this 'new' phenomenon on the cover of an inside section: '"Taki 183" Spawns Pen Pals', the title ran. Many were inspired by Taki and took up the hobby. Simple signatures quickly became elaborate graffiti styles with 3D letters and complex effects.

The concept of competitive self-promotion can be found at all levels and in all disciplines of Hip Hop. The aim is to present your skills through dance, language or visual art, and the quality of the piece represents the artist – more precisely it represents his or her adopted Hip Hop identity. Graffiti writers are always trying to make their names better known and visually more impressive.

Hip Hop made its way across the Atlantic with the help of American soldiers based in Europe and – probably most importantly – though increasing exposure at the cinema. The movies with the biggest impact on the European scene were *Style Wars* (1983), *Beat Street* (1984) and *Wild Style* (1983), which remain popular within the Hip Hop scene as documents of their time, illustrating the beginnings of the graffiti movement in New York. When these films were originally shown on European screens, they triggered the birth and boom of the European graffiti scenes.

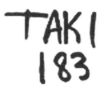

Taki 183's influential tag.

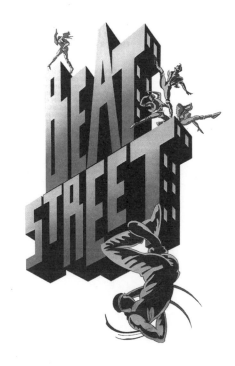

The cover of the 1984 soundtrack that accompanied the movie *Beat Street*.

Finding a definition

Since graffiti has existed for so much longer than the spray can, careful definitions that do justice to its history need to be formulated. Any definition needs to take into account not only that graffiti has existed in one form or another for thousands of years but also that graffiti as we know it is a mass phenomenon, with the spray can as its icon and medium.

	1. Historic graffiti	2. Modern graffiti
Why?	Self-expression, communication	Self-expression, aesthetic pleasure
What?	Names, characters, phrases	Predominantly pseudonyms, characters, phrases
Where?	Public space	Public space
When?	From 3,500 BC in Egypt	From the late 1970s, with roots in New York
How?	Scratching, chiselling, painting, carving, etc	Spray cans, permanent markers

'Communication' is replaced by 'aesthetic pleasure' in the definition of modern graffiti because the communicated message of modern pieces is rarely more than 'I was here'. Also, the effect of Hip Hop's competitive nature has turned aesthetic value into a more central factor, as the finished work is evidence of skill.

Another difference between the two definitions is the way in which the graffiti is created, something due mainly to the differing tools and technology of its era of production. Also, the threat of legal redress (in cases of illegal graffiti) has led to the increased use of pseudonyms.

The graffiti scene today

Within the scene there are five ways to acquire fame and make your pieces stand out from the crowd: quantity, quality, location, size and continuity. (See the pictures on the pages that follow for examples of the first four.) Continuity refers to the consistency with which a writer spreads his or her name around the urban space over a period of time, and this has an effect on both reputation and the respect received from the graffiti community. If a tag reappears over many years then the name will begin to stick in the mind of the onlooker. This continuity – a kind of productive stamina – is a key to success in all forms of graffiti.

In order to achieve recognition within the scene by legal means, your focus should be set on the artistic merit of your graffiti. Many young writers who spray illegal graffiti stop their careers after being caught, and this is another reason why doing graffiti legally doesn't necessarily mean less fame in the long run. Usually it is the only way to enjoy this hobby for an extended period of time without facing severe consequences.

The quality of a graffiti piece is for the most part determined by the style of the letters, followed by the effects and the colour combinations applied to them. Style is the highest quality criterion within the scene because a good style can do without effects and colour, whereas you cannot make up for a weak style, even with the best colours and effects. It is expected that every

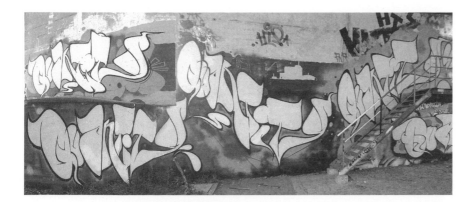

Impressive graffiti in terms of quantity.

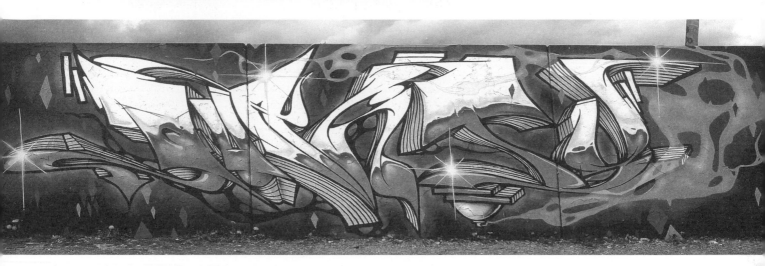

Impressive graffiti in terms of quality.

writer should develop a personal style and not copy too obviously. Every artist is an individual with strengths and weaknesses, and no one's graffiti can be perfect; however, it is expected that an artist who wishes to be taken seriously will consistently try to improve and adapt his or her individual style and skills. Initiative and creativity are the two most important characteristics of a good graffiti writer.

There should be a common respect among writers for each other's work. Even at legal walls – or 'halls of fame' as they're often known – painting over another writer's piece is acceptable only when the older work is already defaced or timeworn, or if the new piece is better than the work that's being covered up, though this is of course subjective. Some writers take it personally when their work is painted over. Walls are usually the front line in conflicts between graffiti writers. Battles are fought by destroying each other's work and by writing messages next to crossed-out pieces. It's sad to see, and is normally a waste of good graffiti. So long as a proper level of respect is shown, battles will be rare. Thankfully open confrontations are even rarer.

A strong sense of solidarity and team spirit exists between graffiti writers, and those who become good friends may decide to join forces and form crews. Many advantages come with being part of such a group. For example it is much easier to get noticed as part of a crew, and it means you will have a network of friends supporting you and looking out for you. Also, active writers travel a lot, visiting other cities to paint. Since this can be costly, travelling artists often rely on other writers to offer free accommodation. These visitors are usually cared for by local writers, and further friendships emerge from graffiti contacts.

For many years the international scene has encouraged this group ethos by holding graffiti meetings and competitions. The most famous is probably

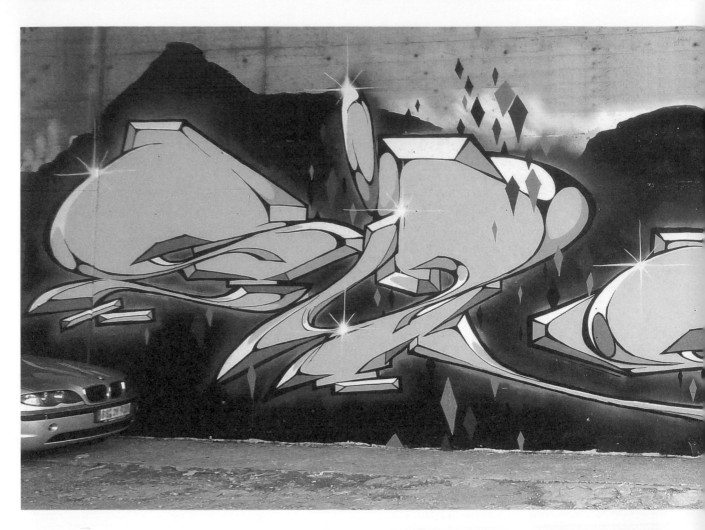

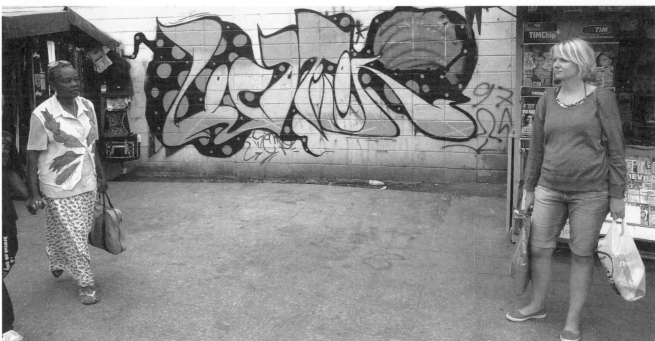

[**Top**] Impressive graffiti in terms of size.

[**Above**] Impressive graffiti in terms of location.

Write4Gold, the unofficial world championship, which stages pre-elimination rounds on five continents. There are other international events, such as Meeting of Styles and Just Writing My Name, where the scene comes together to paint and show its newest styles. Even though the techniques, preferences and interpretations of modern graffiti differ between individual scenes and writers, the artistic quality seen at these events is generally very high and always improving.

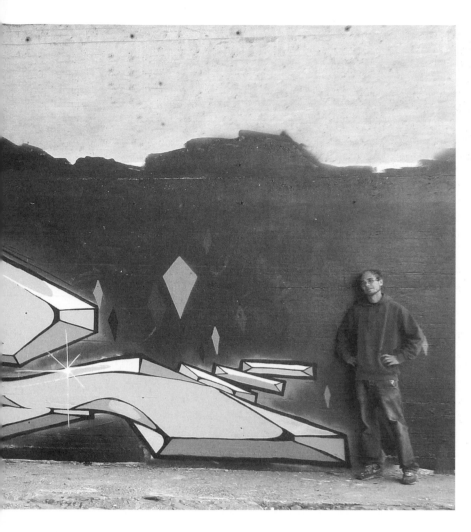

The motivations for painting graffiti are just as numerous as the variety of letter styles that can be sprayed. A craving for recognition is certainly the general incentive for most graffiti artists but there are also distinct reasons why individual writers feel attracted to the medium: some paint for the sake of creating art; some enjoy spending time painting with friends; some see their actions as a political statement; and there are even some who get an adrenaline kick out of painting illegally and causing damage. This range of driving forces explains why the teenagers who choose to start writing graffiti do not all emerge from a single social class but rather come from all levels of society.

When discussing modern graffiti it is no longer appropriate to use the title 'Hip Hop graffiti'. Graffiti was a central medium of the Hip Hop movement; however, the Hip Hop movement has never been a prerequisite for expression through the medium of graffiti. No matter whether it's Hip Hop, Punk, Electro or Heavy Metal that's most popular with youth culture at a given time, graffiti will still be an active form of self-expression; graffiti is not limited to one style of music, it can take colour and inspiration from whatever is current. Wherever you're from, whatever your background, it's possible to discover a fascination for spray-can art.

The legal side

Painting on property illegally is criminal damage and something police and premises officers are increasingly targeting through CCTV and checks. When you add the ever-present risk of being seen by the public, it's clear that unlawful graffiti is at best a game of chance. In order to convict graffiti writers, many cities and councils have now set up their own specialized graffiti task force. These organizations use technologies such as night vision and motion sensors, as well as barbed wire, watchdogs and even helicopters to make

successfully painting graffiti (especially on trains) increasingly difficult. To gather evidence the police can carry out house searches, use security camera footage and even take fingerprints and DNA samples. Police investigations tend to catch inexperienced writers easily.

Remember, graffiti is only legal if:

[1] It is on an explicitly legal wall (a hall of fame).
[2] You are the owner of the wall.
[3] The permission of the owner was given to you beforehand.

Anything else can lead to an investigation by the police. Of course there will always be grey areas, certainly not all illegal pieces are reported to authorities, but the laws are very clear.

If the police (or a graffiti task force) catch a suspect, he or she is questioned (alone) and then given the chance to make a statement. If the suspect denies the graffiti, and does not incriminate him- or herself during the interview or the statement, then it becomes the job of the investigators to find proof. Witnesses, fingerprints, paint stains (on skin or clothing), surveillance camera footage and even DNA analysis can all be used to prove that a sprayer is guilty. Should the police be interested in finding more evidence or want to link other illegal graffiti to the apprehended writer, they can perform a house search. If incriminating objects (such as photos or sketches) are found, the investigation may well be broadened. In the end, a court date could await the suspected offender.

In most countries, illegal graffiti in public space is considered damage to property and penalized as such. Fines may be imposed on the writer and, theoretically, so may a prison sentence of up to a few years; however, the harsh punishment of imprisonment is reserved for repeat offenders whose behaviour is not expected to improve. Teenagers and first offenders are sentenced mostly to community service and/or small fines. Although even a small fine, when combined with court fees and the cost of a lawyer, can become an amount that will take the convicted sprayer many years to pay off.

Depending on the situation, it is possible that a civil law claim for compensation for the damage done may also arise. The aggrieved party, in this case the owner of the wall or the painted object, demands reimbursement – often a larger amount of money than any fine resulting from a legal trial. For instance, a train company that has had carriages sprayed can not only demand to get the cleaning cost refunded but also charge for all the work that was needed to take that train out of service, as well as remuneration for lost earnings ensuing from removing the train from service for cleaning. Some legal systems call on the perpetrators of illegal graffiti to clean off (often by painting over) their own work, so long as this is possible and safe.

If painting over the piece is not possible (especially the case when the unlawful spraying occurred on stone, metal or glass) then specialist cleaning companies have to be hired to chemically remove the graffiti. The size and the nature of the surface to be cleaned will determine how high the cleaning costs are. Flat and non-absorbent surfaces are usually easier and thus cheaper to clean than rough and absorbent surfaces because the paint cannot enter the material and so can be easily removed with solvents.

A civil law claim will need to be pursued by the wall's owner, which means that unless they submit a complaint, no compensation for damages can be demanded. This is important for two reasons: firstly, sometimes no

case can be filed because it's impossible to determine the owner (often the case in so-called 'semi-legal' spots such as abandoned buildings, ruins and houses waiting for demolition); and secondly because it gives a graffiti writer an opportunity to contact the owner of the wall and ask to settle the issue without going to court. Even if no complaint is recorded, illegal graffiti can still be pursued under penal law if the police document and record it out of their own initiative.

Although some legal systems still treat the offence of graffiti as 'malicious damage', this seems perhaps a little harsh. The function of a bridge or train is not affected if it is painted: the bridge does not collapse because of the graffiti on it and the train will still get where it is going. Instead, some legal systems have introduced 'defacing' as an offence specifically to combat graffiti. Defacing is defined as the permanent, visual changing of something without permission – it's a much better definition of graffiti than 'malicious damage'.

In most countries spray cans and graffiti accessories can be purchased by anybody without age restrictions. Countries such as the United States have more strict policies and limit the sale to adults. Certain areas have their own unique rules, for example in New South Wales, Australia, and New York City, United States, it's illegal for anyone under the age of 18 to carry graffiti implements.

It's possible for magazines and books to feature illegal graffiti on trains or walls, so long as the publications dissociate themselves from any unlawful content and do not encourage others to perform similar actions. Freedom of the press means that any coverage documenting (rather than promoting) this art form cannot be forbidden. Despite this, Australia, France and Germany have all at one time or another tried to ban certain graffiti magazines and DVDs. In most cases they had to give way due to complaints and pressure; however, on some occasions the attempts of the authorities were successful and the products had to be taken off the market.

Not all countries and cultures take as negative a view of graffiti as the developed industrial nations of Europe and North America. Parts of South America and of Asia have a much more relaxed approach to graffiti in public spaces, and though anti-graffiti laws may be in existence they are seldom enforced. There are a number of reasons for this. For one, there are cultures that do not see graffiti as necessarily a public nuisance or crime but regard it – maybe due to their different perception of property – as an artistic expression that does not need to be forbidden. Other reasons can be the indifference of the authorities or ineffective police work. Furthermore, there are countries that simply have bigger problems than chasing teenagers who spray paint on walls.

Illegal graffiti may seem tempting and exciting – especially to beginners – but it's easy to underestimate the consequences you might face if caught and sentenced. Besides any costs that might need paying, a conviction can cause problems in the long term: limitations when selecting a career can be far more painful than community service or a fine.

[2] Theory

When discussing graffiti it soon becomes clear that special terms are needed to help describe the different kinds of pieces that exist, as well as to refer to the individual qualities of the artworks themselves. Graffiti is incredibly varied and works can differ in size, complexity, colour, location and the time needed to create them. These features are the basis for the categories or disciplines that we use to divide graffiti.

It's useful to have graffiti terminology to hand for theoretical discussions, as well as practical ones. Graffiti is a worldwide medium that links a huge number of talented artists in a network, and being able to discuss active writers and recent styles is a part of being a member of the scene.

Graffiti terminology

Graffiti terminology mostly refers either to the complexity of the work or the medium on which the work is sprayed.

Complexity

The primary and most simple form of graffiti is a signature; this can stand alone and is called a *tag*. Tags are executed in a couple of seconds and are often decorated with additional designs. Tagging helps a writer to spread his or her name quickly.

It's not easy standing out from a crowd of tags.

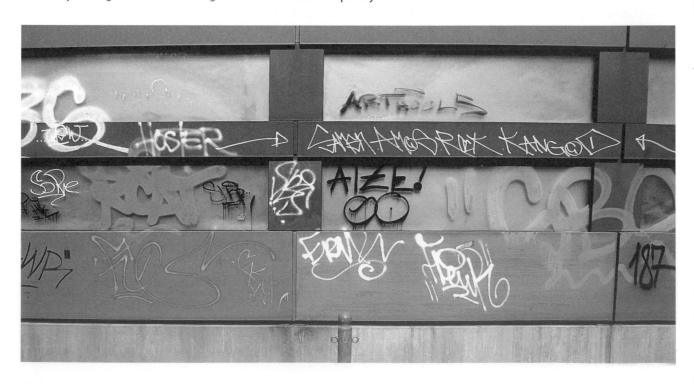

A silverpiece throw-up by Geo.

The next category, in order of increasing complexity, is the *throw-up*. As well as being bigger and covering more space than tags, the most fundamental difference is that only the outlines of the letters are drawn, rather than a single line representing the letter itself. The style of throw-ups is characteristically simple, often mixing massive letters with quick effects, such as shadows or small lines suggesting movement. Throw-up letters can be left blank, shaded or properly filled, and normally take just a few minutes to create; however, because of their size they're more eye-catching than a tag.

A more complicated throw-up, with multicoloured fill-ins and perhaps a background, completed within 10–15 minutes is called a *quick piece*.

Silver chrome spray paint is very popular among writers because it gives the best coverage of all the colours, and thus is chosen for fast and cheap fill-ins. Pieces featuring letters filled with silver chrome are called *silverpieces* or *chromies*, while *full-colour* pieces use a number of different pigments.

A *rollerpiece* consists of simple graffiti letters painted using wall paint and paint rollers. Telescopic extensions can be used with the rollers to paint spots that are hard to reach.

Clean letters without elaborate details are called *simple styles*. Lettering with inconsistent and exaggerated proportions is known as *ill style*. Complicated letter combinations with connections, arrows and additional designs and effects are referred to as *wildstyle*.

Location

To correctly assess the quality of a graffiti piece it's important to take its location into account because this can reveal a great deal about the circumstances in which the work was painted. Ascertaining whether or not the piece was painted legally or illegally is important; a sprayer may work

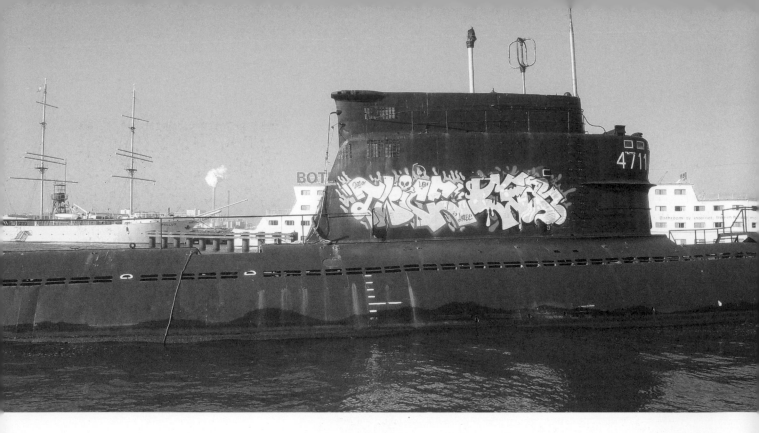

Not even submarines are safe!

on a legal wall at daytime without any pressure or risk, whereas an unlawful painting would have to have been completed quickly in adverse conditions. Works completed on legal walls are called *hall of fame pieces*. If an artist is given guidelines and paid to create specified graffiti the work is known as a commission.

The urban practice of *street bombing* focuses on typically inner-city surfaces such as building façades, roller doors, transformer stations and bridges. Trucks and rooftops both count as individual categories. The risk involved in street bombing cities means that it is mainly overnight tags and throw-ups that appear. When evaluating another writer's work, graffiti artists take risk into account. Among illegal writers, graffiti pieces in busy, prominent or hard-to-reach spots are valued and respected regardless of quality. Nothing is safe from a writer looking for extreme locations.

Trains are and have always been a popular target for illegal writers because they carry the sprayer's name through the city for all to see. (Although nowadays, in the networks of large cities, sprayed trains are often pulled out of service and cleaned within a couple of hours.) Graffiti on trains is described according to the size of the piece or the kind of train the graffiti is on. A detached piece predominantly below the windows is called a *panel*, while a completely covered wagon is called a *wholecar*. There is more terminology relating to pieces on trains listed in the glossary on page 172.

Media

There is a wide variety of graffiti-themed publications to be found at shops and websites that specialize in graffiti or Hip Hop products. Magazines and books featuring high-quality graffiti have always played an important role in spreading interest and communicating styles, and now there even exist computer games, social networking sites and movies relating to graffiti culture.

Before access to graffiti media became as straightforward as it is today, writers were influenced by local artists, which led to varieties of local graffiti that made it possible to recognize specific styles and guess their origin. Today this is possible in only exceptional cases because international magazines and the internet have replaced local role models.

Films

Hip Hop's initial wave of popularity in Europe was due to American films such as *Style Wars*, *Beat Street* and *Wild Style*. These were the first mass media to show and popularize the Hip Hop lifestyle and they inspired the graffiti pioneers of Europe. More recent productions that take graffiti as their theme have struggled to repeat the success of these definitive oldschool films.

Nowadays it is more common to see self-shot (and mostly illegal) graffiti exploits, edited into short sequences that are collected together and made available in shops or published on the internet. Some have audio commentaries and background stories; however the pressures of filming unauthorized graffiti – often quickly and in poor light – make achieving professional-standard footage very difficult.

A huge number of TV documentaries have been shot over the last 20 years, and many of these are now available (not always legitimately) on the internet. The positions that these documentaries take on graffiti range from demonization and rejection to approval verging on deification.

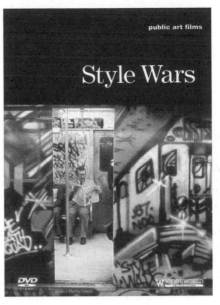

[**Above**] The cover of the *Style Wars* DVD.

[**Left**] Poster advertising the movie *Wild Style*.

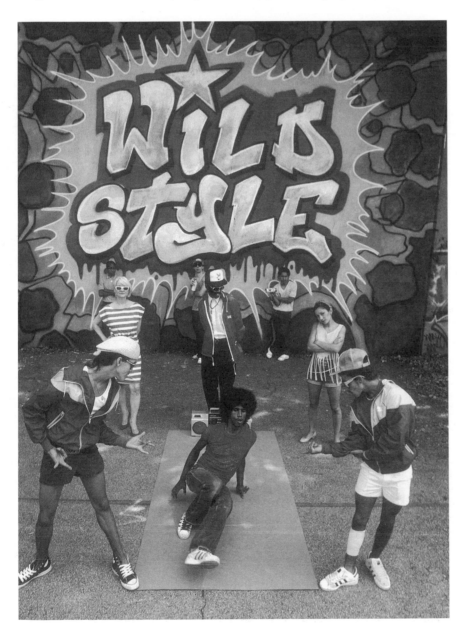

Magazines and books

Apart from the three classic films already mentioned, print has been the most significant graffiti medium. Of the many books published on the subject of graffiti, the most important and influential was probably *Subway Art* (1984) by Henry Chalfant and Martha Cooper. In nearly three decades no better guide to the original New York style has emerged.

As young writers rarely had the money to buy expensive books, magazines flourished in the 1990s and early 2000s, and although cheap or free content hosted on the internet has recently caused financial problems and closures for many periodicals, a number of international graffiti magazines still exist.

In some cases, the sprayers themselves have taken to creating and distributing fanzines featuring local photo selections. These are typically run as not-for-profit publications as the scene is small and poorly funded. For these smaller magazines, the motivation is supporting the scene by offering a platform for communicating extraordinary art.

Modern graffiti books are becoming increasingly specialized, dedicating themselves to certain regions, artists or styles.

Some of the graffiti magazines available.

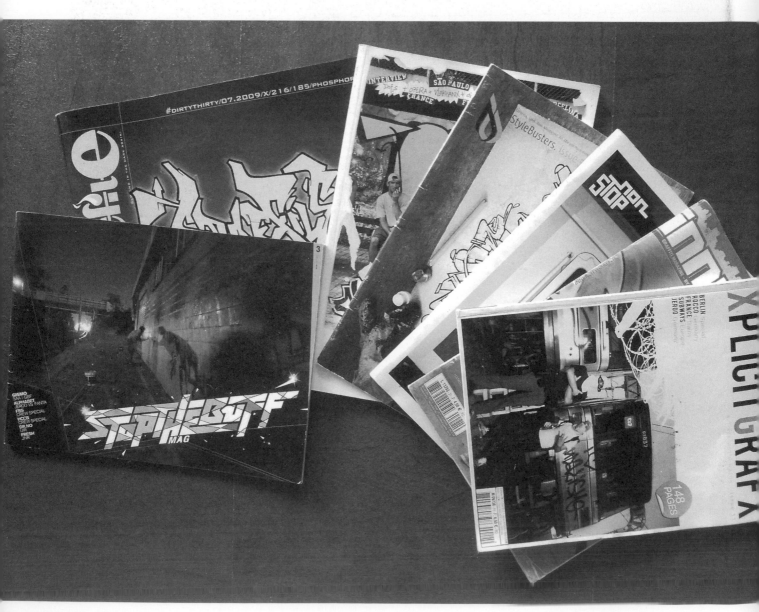

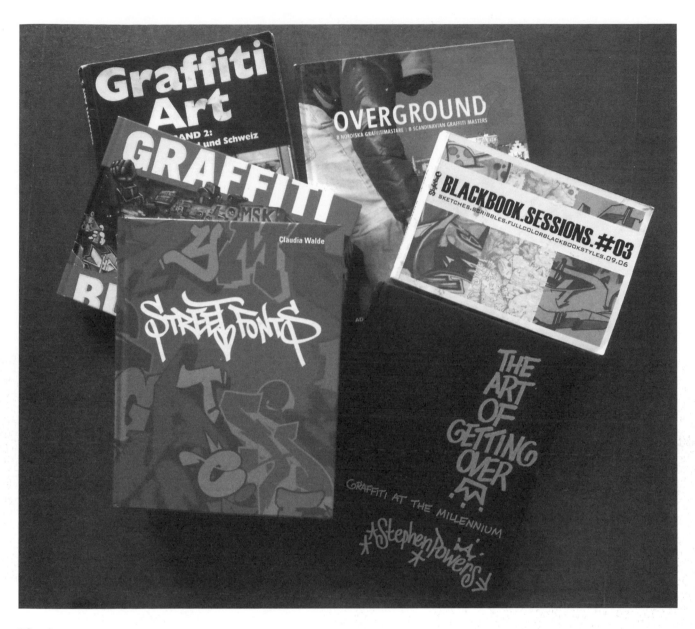

Some of the graffiti books available.

The internet

The internet is now, and for the foreseeable future, the best way to access information about graffiti; there are hundreds of dedicated pages, as well as chat rooms, photo galleries, blogs and social networks that provide free platforms for showing your latest graffiti, or viewing that of other individuals. Writers upload new photos every day to promote their work, and with finished pieces by world-class writers so easily accessible, there is plenty of scope for improving your own skills by examining the latest techniques and developments of others. The internet is also used to communicate and spread news: writers might be able to find out information regarding nearby legal walls, upcoming graffiti gatherings or even where to get good spray cans. You can find some useful graffiti links listed at the back of this book.

The ease with which images can be added to the internet is not always an advantage, as some people will upload photos of any piece they find, which can cause problems, especially with illegal pieces. Not every writer wants his or her pieces to appear on the world wide web, as the police also observe these platforms to gain information. There have been cases where careless comments have caused convictions.

[3] Designing graffiti

Trying to create beautiful graffiti for the first time, you'll quickly realize that it isn't as easy as some make it look. Randomly adding pointless elements such as crooked lines in order to achieve complexity is certainly the wrong way of setting about graffiti design. A better approach is to interpret and artistically extend pre-existing elements of the basic letter structure.

This chapter outlines the key methods of transforming normal letters into graffiti styles. The essential disciplines and techniques are explained, and step-by-step diagrams show how to go about forming and developing sophisticated tags, throw-ups and letter styles. You'll also learn about important text effects, such as adding shadows and 3D blocks.

Many burners (large, time-consuming and elaborate pieces of graffiti) are likely to begin life as small-scale sketches in pencil or pen.

Sketches

Drawing preliminary sketches on paper is the best way of working up lettering. Graffiti styles are almost always tested and developed in sketchbooks before being sprayed onto walls.

Beginners should focus primarily on learning to handle the new tools and concepts of graffiti design on paper, improving their technique rather than starting by trying to design letters out of the blue at the wall; that kind of improvising – known as freestyling – is the domain of advanced graffiti writers. Unlike spray-can graffiti, sketching requires only paper, pencils, an eraser and a couple of fineliners with different widths of stroke.

The aim of sketching on paper is not to create 'final' artworks, but to work out a draft that can later be realized on the wall. It is a time for training and trialling. As you sketch consider the opportunities specific letters offer. How can they be connected? Where might you add additional elements? Do you prefer certain scales and proportions?

Sketches are the most effective way of improving your style, so don't worry about making them perfect straight away. At this stage it's better to draw plenty of quick black-and-white sketches, rather than spending too much time on precise designs.

Colouring in your first graffiti sketches isn't necessary, because:

- For now the focus should be on the shapes and styles of the letters.
- Pen- and pencil-based colouring techniques are totally different from the techniques you'll use when spraying with a can.
- Paints aren't suitable because thin, clean lines are hard to achieve using brushes.
- Using a brush to apply an even coat or blend paints into one another requires a lot of training; however, it's simple to do using spray cans.
- Paints and alcohol-based design pens are expensive.

Copying

Copying another writer's letters is called 'biting'. Most advanced graffiti artists frown on biting, but it is a good starting point for beginners. Often, biting a few key letters from another artist's piece entails more work than just plain copying: the missing letters for your own name will have to be designed to fit in suitably with the original style. Furthermore, the letters will have to be rearranged and reconnected, which is a challenge for any writer.

Most writers have bitten another writer's ideas at some point over the course of their career, and it's acceptable so long as it is not done too obviously. Copied elements should be adapted and incorporated into your own style – in this way they become individual again.

On pages 163–70 you will find some complete alphabets by experienced writers. Copy letters, but remember – be creative!

Tags

Tags are the origin of modern letter style; they are also the best place to start learning about the practice of hands-on graffiti because a good tag should clearly display all the general rules of graffiti lettering. The relatively reduced complexity of tags means basic skills such as composition and proportion can be seen clearly and understood better than in larger throw-ups and outlined letters.

Executing a graceful tag requires an even stroke of the hand, and the ability to create clean lines is vital when it comes to writing your own work. Curved lines with an even swing make a tag look elegant, yet it's important that individual lines and strokes look stable, meaning every curve should be balanced by a counterpoint heading in the other direction. Without counterpoints, lines can appear unbalanced and look crooked instead of harmonious. Tags and outlined letters require spontaneousness and flexibility. Writers develop their tag over many years and keep changing details constantly. They often fill whole books with small tags just as a form of practice

When designing your own tag, try to combine accuracy, elegant lines and reasonable composition. Once you've mastered this it's time to start changing the look of the letters: playing with the letter shapes, proportions and decorative elements. At this early stage in your graffiti career it is better to experiment with lots of different names and letter combinations, rather than concentrating on just one word.

Practice will help you to draw a clean, confident line.

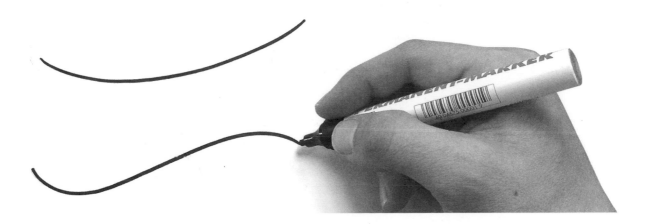

The letters of the alphabet are made up of a few recurring elements that can be interpreted in certain ways. For example, letters such as B, C, D, G and S all contain semicircles or bends, and these curves can be portrayed differently. Depending on your chosen style the curves could be designed to look round, flat, angled or emphasized with unusual proportions. To achieve a consistent style of lettering, those recurring visual stresses should all be executed in a similar way. The letters in the following example show how a particular style can be made consistent across various letters.

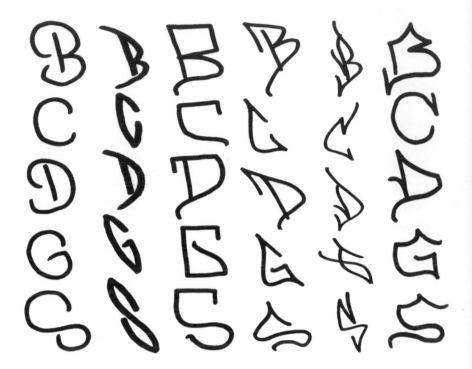

The style of the following tag alphabet depends on two characteristic features: horizontal lines and curves are replaced with pointed arches, while vertical lines generally remain straight.

[**Alphabet style**] Pointed arches and straight vertical lines

Tag design

There are many decisions to be made when designing letters for your tag. Type fonts – the printed letters found in any book or magazine – have stylistic features that may all be used when sketching out tag concepts. The attributes of particular fonts are the starting point of letter beautification.

The following examples show the typographic elements that can most easily be borrowed from print to help you with creating a more distinctive tag design.

Serifs. These are small strokes added to the ends of longer letter elements. They give the character a cleaner and more stable look.

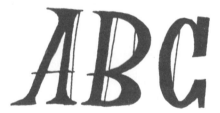

Stroke width. Some fonts use differing widths of line to form individual letters. Varying stroke width can help letters look more lively and sophisticated.

Hairlines. Adding a thin hair stroke parallel to the main stroke makes letters appear more finessed and detailed.

When putting the finishing touches to your tag design there are two important questions you should ask:

- Do the letters fit together stylistically?
- Is the tag readable? Legibility is preferable, though not strictly necessary; if you can work out what the tag says, then the individual letters will become recognizable.

On the following pages is a collection of the most popular forms of letter styles for tags. The effects shown can be used individually or interpreted in combinations. It's worth trying out each of the possibilities with your own name before settling on a final style, or combination of styles. As a tag becomes better known, it should be recognizable from a single letter.

[Exercise] Tags 1

Think of the name that you want to write (it shouldn't be longer than five characters). Then complete the following styles, but using your own name. You will need a normal pen and a fineliner for this exercise.

TAGS

Unstyled printed letters – the starting point.

[1] The first and the last letters are drawn larger than the rest.

[2] The letters are arranged so that they sit on different baselines.

[3] The letters are drawn so that they sit close to one another.

[4] Curves are replaced by bent lines and angles.

[5] Serifs are attached to the letters.

[6] Curving lines replace straight ones.

[7] Uppercase capital letters and lowercase letter styles are combined.

[8] The proportions of some elements of the letters are altered.

[9] The letters are drawn so that they partly overlap one another.

[10] Single lines are extended outside of the text area.

[11] Letters are connected as closely as possible.

[12] The ligatures between the letters are used to create extra shapes and loops.

[13] Letter elements are omitted (but the letters remain recognizable).

[14] Backslanting letters.

[15] Letters are given a mirror effect, or shown upside down.

[16] The last letter is extended, and an additional element (such as a spiral, hook or arrow) is added to the end.

[17] Empty space is filled with designs, such as stars, halos and arrows.

Additional effects: a thin fineliner can decorate a tag.

[18] The tag can be outlined.

[19] Lines can be added indicating a background or movement.

[20] A thin shadow can be added.

[21] A stylized, discontinuous shadow can be added.

[22] Letters can be defined by their shadows alone.

[23] A 3D-block outline can be added.

[Exercise] Tags 2

[1] Draw an elegant handwritten (cursive) tag using long swings. For example:

[2] Draw an aggressive-looking tag using pointed angles and spikes. Extend some elements to make the tag look jagged and energetic.

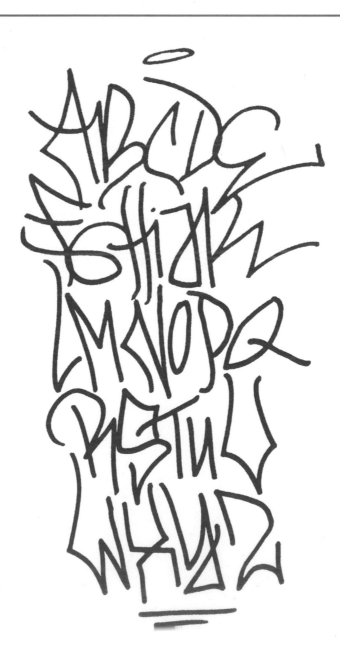

[Alphabet style] Jeroo custom

There is an almost infinite number of ways to draw every single tag. The way its letters are constructed, their proportions, additional illustration elements and connections allow for any number of interpretations. As long as the letters remain recognizable, everything is possible! One letter that can be drawn in an especially wide variety of ways is S. Here are a few examples:

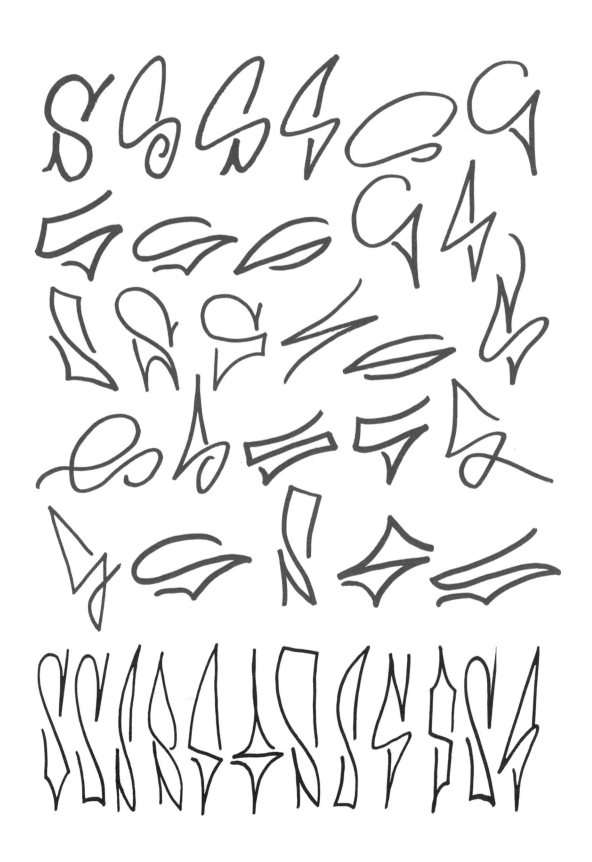

[Exercise] Tags 3

The following task is designed to help you learn how to continue a certain letter style. Before you start, look at the way the filled-in letters are designed – what are the characteristics and how might they be applied to the missing letters? Complete the tag alphabet in the correct style.

Solutions are shown on page 154.

Tag endings

Letters are often ornamented with additional symbols or punctuation marks that round the piece off or fill empty areas – these marks are called tag endings. Some letter structures (such as E, K, L, R and Y) are especially suitable for the inclusion of extra elements at the terminals. Here the letter R has been given some classic tag endings.

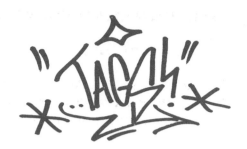

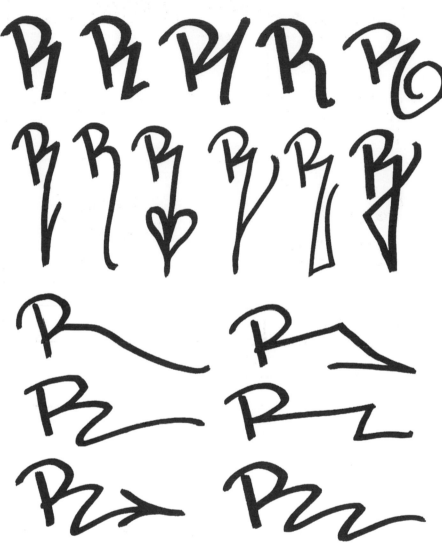

Tag stars Three different kinds of star are used to decorate tags.

five-pointed six-pointed four-pointed

Tag arrows There are many ways of drawing arrows when tagging, but the arrow used in most classic tags has a loop at the tip.

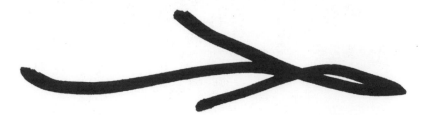

Crowns and halos Both indicate a respected and 'untouchable' writer. A halo added to a tag (or a tribute piece) may signify that artist has died.

Calligraphy tags

Calligraphy pens have a flat tip, which makes drawn lines thicker or thinner depending on the direction the pen moves. Writers can purchase special calligraphy caps to get this effect when tagging.

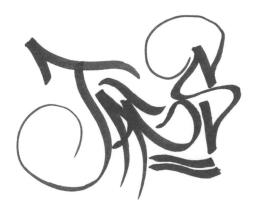

Calligraphy-style tags

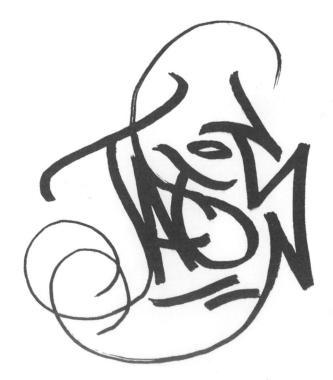

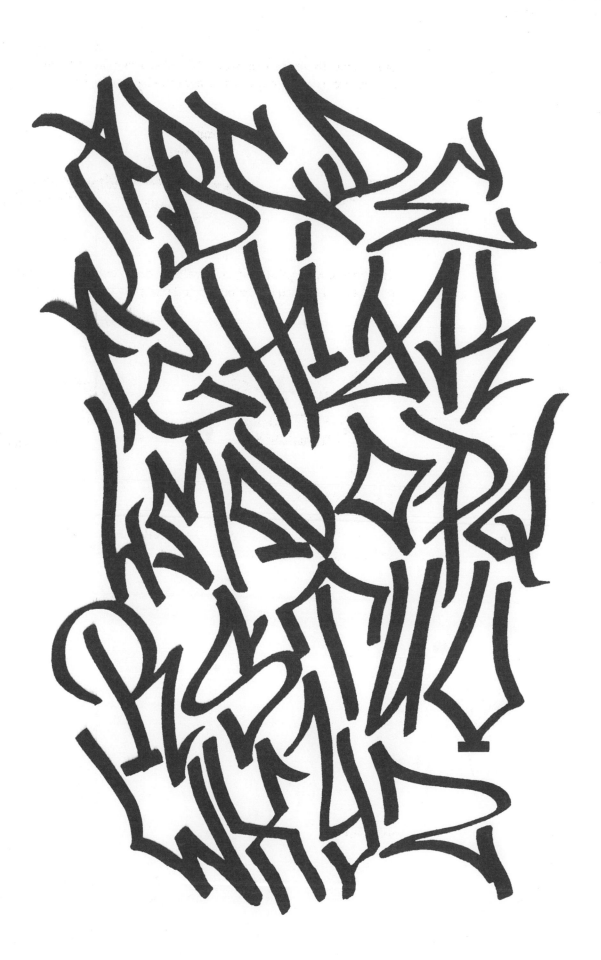

[**Alphabet style**] Calligraphy

Advanced tags using calligraphy-style contrasts and additional hairlines.

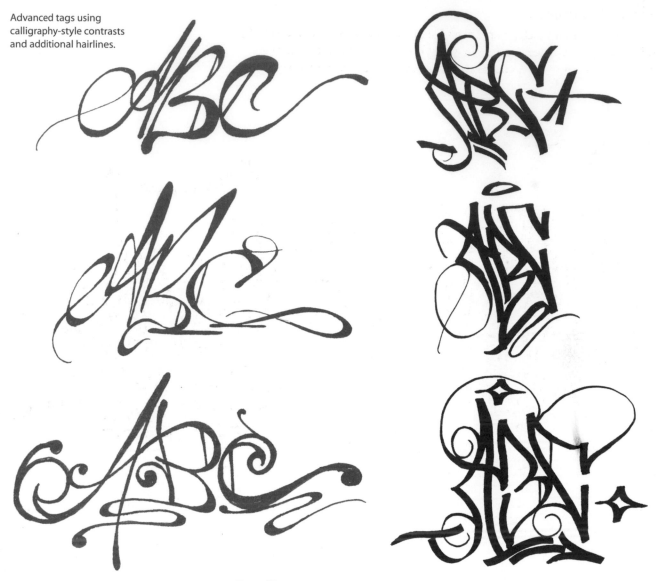

One-liner tags

As the name suggests, one-liner tags are drawn using a single continuous line. Not all capital letters or tag letters are suitable for one-liner tags, and some may need to be replaced or adjusted. Taking the replacement from handwritten-style lettering is ideal because 'joined-up' letters are designed to be composed in an unbroken flow, making them easy to combine using one line.

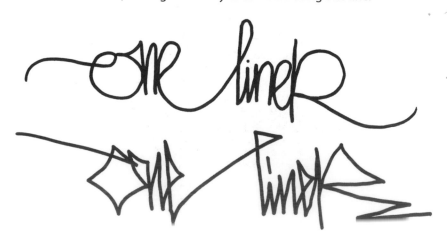

Tags with character

This exercise is about picking up on the literal meaning of a word and visually representing it in the tag. Try to fit or adjust the shape of the letters or the word to its meaning. You could decorate free space with appropriate designs.

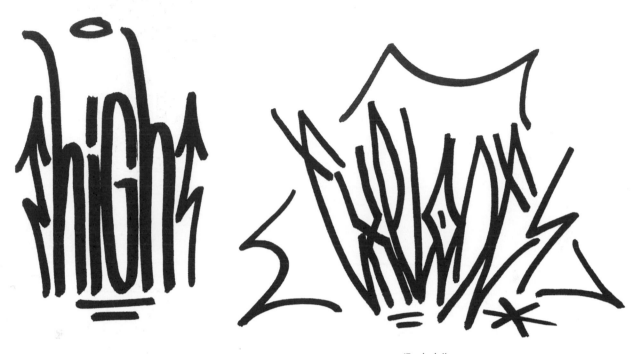

'High' 'Explode!'

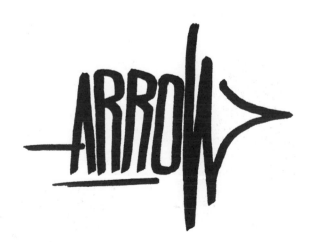

'Space'

'Arrow'

[Exercise]
Tags with character

[1] Try drawing tags that represent these words:
a) 'Long'
b) 'Short'
c) 'Mirror'
d) 'Smooth'

[2] Pick your own words!

Throw-ups

While tags are composed of letters drawn with lines, throw-ups are made from letter outlines, meaning that just the edges of the letters are drawn. These throw-ups can be left unfilled (on a plain background) or filled in with a single colour. The step from tags to throw-ups opens a new dimension of possibilities, such as overlapping or outlining letters.

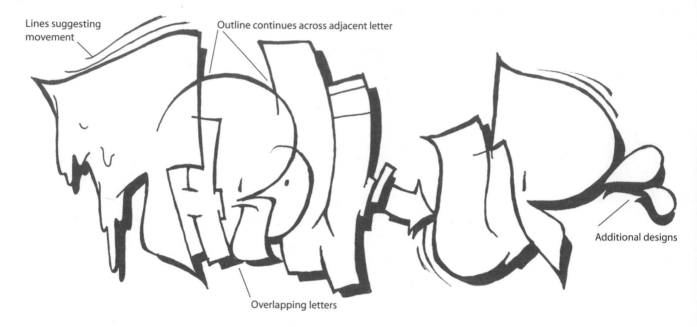

Lines suggesting movement

Outline continues across adjacent letter

Additional designs

Overlapping letters

Throw-up lettering can become complex and contorted, but normal-looking letters are still the raw material for every design. The most simple form of throw-up uses capital letters, or blockbusters, as they are called within the scene.

Blockbusters are typically made up of straight lines surrounding thick, single-colour elements. No additional designs or distortions are used when drawing blockbusters, which means they are easily the most legible form of graffiti. The concept itself could not be clearer: once a large capital letter is outlined in another colour, a basic blockbuster letter is formed.

Taking the outline of a printed capital letter provides the basis for a blockbuster.

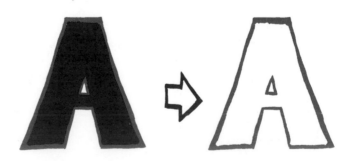

One basic yet important principle to keep in mind when drawing letters is the 'plank' rule. The idea is to visualize a letter's straight-line elements as rectangular boards of equal width that overlap each other to form its shape. You can use the edges of the imagined planks to get the position of openings inside the letter correct. The imaginary boards will also help if you need to extend a line that has been broken up by overlapping elements.

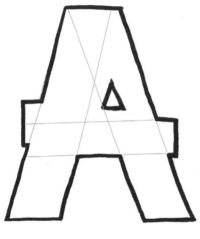

The plank rule.

Wrong

Right!

Designing a throw-up gives you all the same options that tag design did (pages 30–31), though some of them will have to be adjusted to work with the letter outlines of blockbusters. Outlined letters provide some entirely new design opportunities, such as continuing an outline into the next letter ('break-throughs') and overlapping letters.

You can begin to take your blockbusters forwards by adapting the plank rule: imagine that the boards are now different (though still consistent) shapes, rather than just pairs of parallel lines.

Adapting the plank rule.

[Exercise] Throw-ups 1

This exercise shows some additional techniques that can be applied to throw-ups. Remember, you can also use the tag techniques you learned about earlier.

 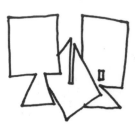

[1] Sketch a three-letter throw-up with planks of varying widths.

[2] Let the letters overlap each other. Remember not to cover up any of the areas that are important for recognizing the letter.

[3] Replace the planks with geometric shapes such as squares, diamonds and rectangles.

[4] Try rounding off the corners of the letters.

[5] Where letters overlap, let the outline of the character below show through on the upper letter.

[6] Reduce gaps and spaces within the letters to lines and dots, so that the characters appear thick and massive.

[7] Add pointed elements to rounded shapes.

[8] Let part of one letter pierce through another letter.

[9] Try to fit the letters next to each other without leaving any gaps.

Even basic blockbuster throw-ups (consisting of simple letters of equal size) can be styled in a number of ways. Rounding effects are popular, but you can also achieve powerful visual effects by using only straight lines and angles.

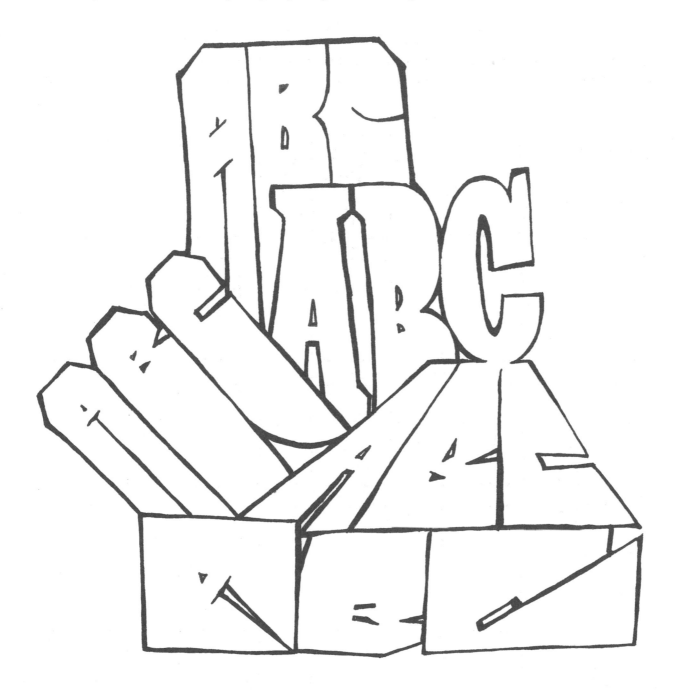

Most of the blockbusters shown above work by cutting letters out of simple geometrical shapes (normally rectangles).

Dividing geometric letter shapes up by adding single lines (rather than introducing gaps) gives the impression that the letters are massive; however, this doesn't work well for all letters. Certain characters – especially D, F, L, P, Q, T and V – require small cuts from or additions to their main geometrical shapes in order to be recognizable. For example, the letter O would otherwise look just the same as a D. Although the letters B, R, K and X do not necessarily need alterations making to their outer shapes, they tend to look better with real incisions instead of only thin lines.

[Exercise] Throw-ups 2

The lines on the inside of a letter shape are vital for recognizing the letter. These lines count as key areas and should never be covered by other elements or letters (see pages 51–52 for more on key areas).

Complete the alphabet below by adding lines (if necessary) to the inside of the shapes.

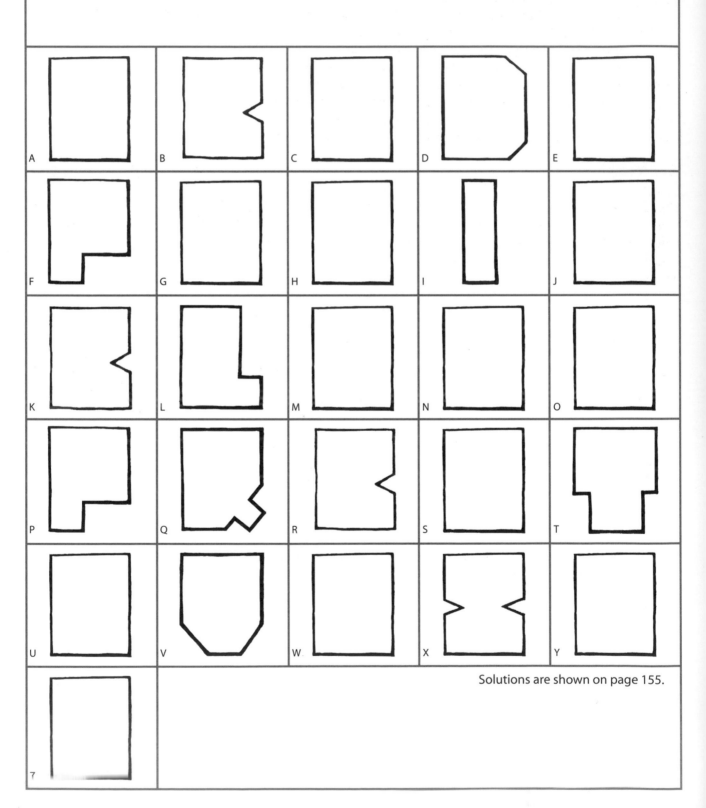

Solutions are shown on page 155.

Outline

A colour that creates a strong contrast with the fill-in should be selected for the outline. This will ensure the piece is distinguishable, and it is why many throw-up pieces have a black or white outline.

Outlines can be completed with either an equal thickness or a varying thickness. A varying thickness helps to bring out a letter's proportions and makes it look more dynamic. The basic rule is that if a letter is 'thick' in a particular area, then the outline there is thick too. This effect can be best shown and practised on simple shapes, such as the oval and the rectangle to the right.

The thick–thin outline helps to convey the shape of a letter by drawing attention to large areas, making them more clear and conspicuous than the small details. A letter's proportions can be strengthened by varying the thickness of the outline. For example, the short side of this rectangle's outline is thicker than the long side to emphasize the proportion – a bit like a material that gets thinner as it is stretched. Following this rule, the longer vertical lines of the letter A are thinner than the shorter and thicker lines at the top and bottom.

Rectangle Ellipse

Letter A Styled letter A

Bubblestyle

The basic idea of bubblestyle is that the letters look as if they have been blown up with air like balloons. The edges are rounded and openings are reduced to points or lines. Letters can either be compact and overlap each other, or can be distended to cover as much space as possible. Often simple additional designs such as arrows, circles and tags are added to fill gaps or round off the outer shape. Bubblestyle letters can be executed quickly due to their round shapes, making them very popular among graffiti writers. The style also leaves plenty of scope for variation and personal interpretation.

The writing above has a bubble exclamation mark. The rounded letter shapes below have pointed terminals, forming a style contrast.

45

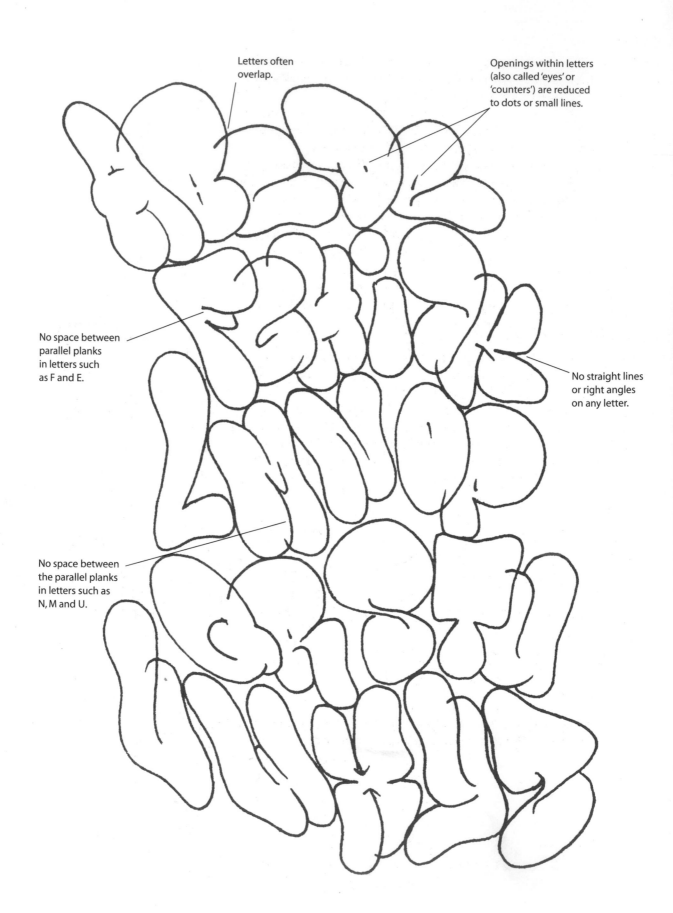

Letters often overlap.

Openings within letters (also called 'eyes' or 'counters') are reduced to dots or small lines.

No space between parallel planks in letters such as F and E.

No straight lines or right angles on any letter.

No space between the parallel planks in letters such as N, M and U.

[Alphabet style] Classic Bubblestyle

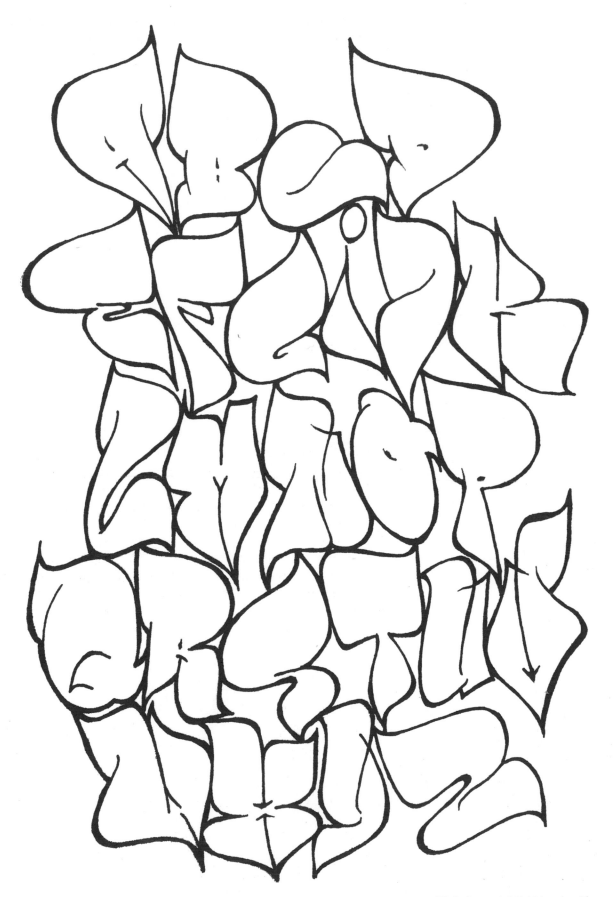

[**Alphabet style**] Bubblestyle with
thick–thin outline and pointed terminals

Wings, drips and underlines are all decorative elements that can be added.

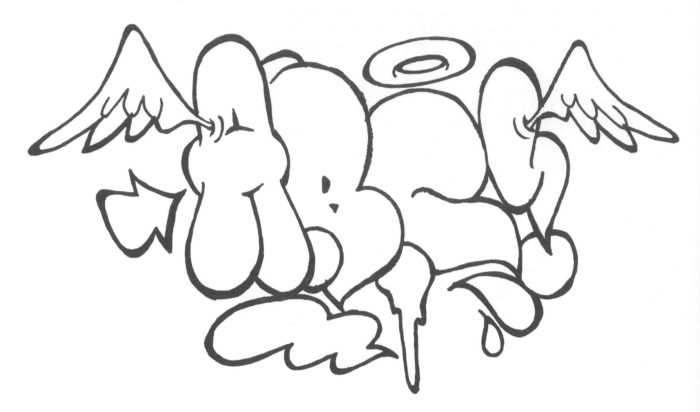

One-liner throw-ups

One-liners are throw-ups executed in one continuous line. This may sound simple but it is highly complicated and may take a lot of work to get right. Every different oneliner has to be completely thought through before you step up to the wall.

A continuous unbroken line requires a completely new approach to the way the letters are constructed. As drawing a one-liner letter by letter is practically impossible, the upper outlines and incisions have to be drawn first, while the lower ones are drawn on the way back. Another problem is drawing the openings within letters, which – if you're following the rules strictly – requires that you draw a line through letters or leave the openings out.

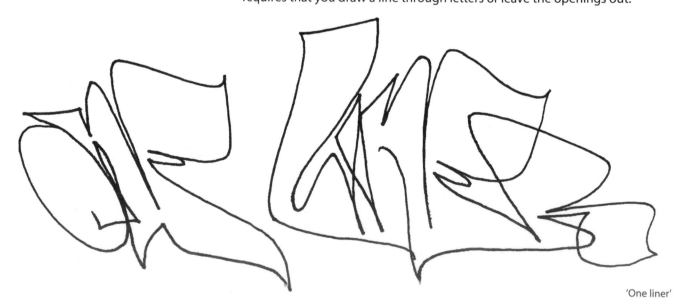

'One liner'

Throw-ups with character

This exercise is about picking a word and managing to depict its meaning within a throw-up. Try to fit or adjust the shape and style of the single letters or the whole word to visually represent its meaning. You can include designs and objects that are appropriate to the word's character.

'Circle'

'Fire'

'Thin'

[**Exercise**]
**Throw-ups
with character**

[**1**] Draw throw-ups for 'tree', 'square', 'wave', 'cloud' and 'thick'.

[**2**] Pick your own words!

[Alphabet style] Jeroo

Styles

Detached letters become a consistent graffiti style when brought together as a word. The way that word expresses the chosen style depends mainly on three elements. Firstly, how the letters themselves are structured and designed. Devices such as connections, contortions, arrows and fragments are all design components that will contribute to the final look of the word. Secondly, the effects used on the letters can alter the overall appearance. A graffiti style can look graphic, organic, figurative, playful, naive, aggressive, dirty or elegant. Lastly, a fitting colour scheme will also have a major influence but, to begin with, this section concentrates on black-and-white sketches.

Graffiti styles are still essentially letter outlines connected to one another, but as the connections become more complex the possibilities grow. When modifying standard letter shapes there are very few stylistic limitations. Anything goes, so long as the letter remains decipherable and the artist is happy with it. There are, however, some guidelines for making a letter look clean and distinctive.

Every letter has its own distinctive structure that makes it distinguishable from the other letters of the alphabet. This structure depends on key areas such as openings inside the letters and the lines indicating touching planks or connecting points.

With graffiti it's crucial that every letter can be recognized, so the fundamental structure must be maintained. You can make alterations, but the letter must still be (theoretically) legible. For example, an 'A' consists of two diagonal strokes that come together in an apex, with a bar in the middle, which leaves a hole (or 'counter'). This means every 'A' needs to have at least a separating line towards the bottom (representing the two planks), which is broken by two small lines (indicating the middle plank). These necessary elements are displayed here in grey.

Distinguishing a letter does not always depend completely on recognizing the outer shape, which means that this element of the letter can therefore be altered in a number of ways.

The following examples show how the outside outline of a letter is not as important as the key areas inside. The key areas of the following letters are all unchanged and consistent, giving the letter its distinctive appearance.

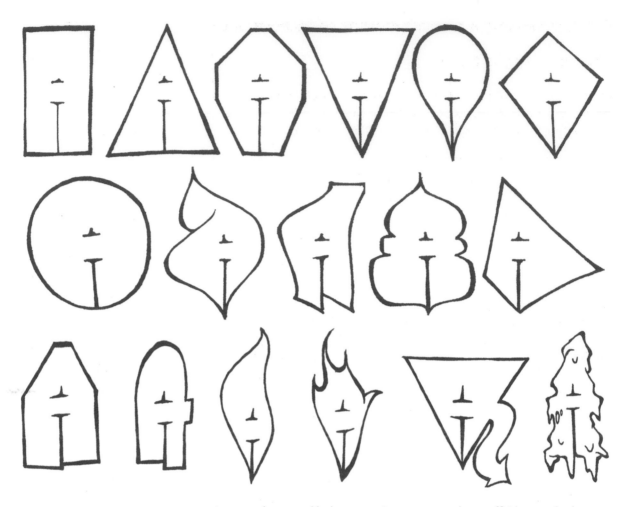

As seen above and below, even in more complex graffiti letters the key areas stay relatively simple in order to keep letters recognizable and decipherable.

[Exercise] Key areas 1

You will remember the principle of 'key areas' from the blockbuster exercise on page 44. A blockbuster S can be created by adding a horizontal line from the right and one below from the left.

This key area can be shortened or extended but the structure remains the same, no matter how the outline of the letter changes. These examples have very different outlines yet still have the same key area.

[1] Draw five more versions of the letter S.
[2] Choose another letter, pinpoint its key area, and then draw that letter three times with different outlines but the same key area.

[Exercise] Key areas 2

Complete these letters by adding the missing internal lines.

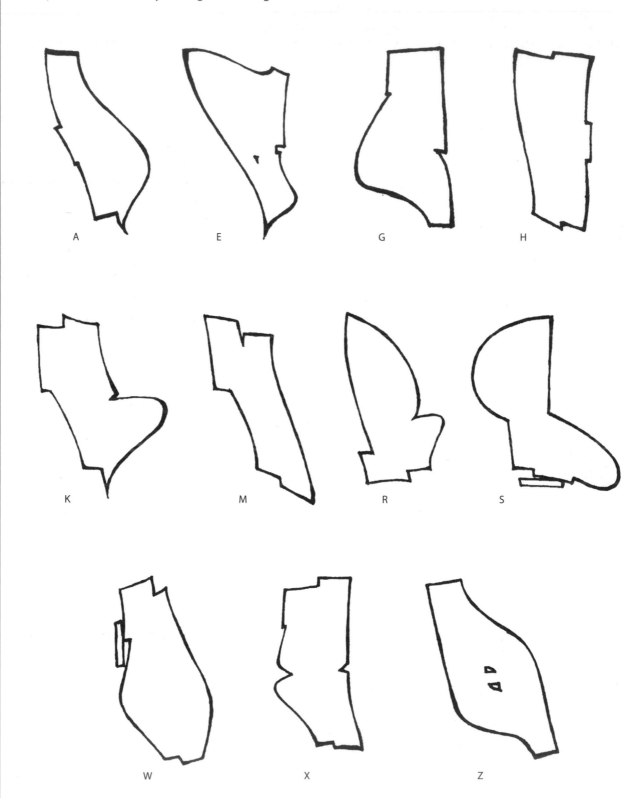

A

E

G

H

K

M

R

S

W

X

Z

Solutions are shown on page 156.

Proportions

In graffiti, changing the proportions of a letter is a way of giving it a new shape without changing the basic structure. The parallel lines that make up each plank and curve of a letter can move closer or further away to vary the thickness of that element.

Varying the proportions is an important way of giving a lively and dynamic feel to your writing. What's more, variable proportions can help when trying to fit letters closer together, or even into one another.

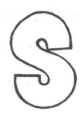

The starting point: an S of uniform proportions.

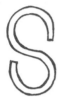

| Thin | Thick | Increasing/ Decreasing |

Changing the thickness of the letter's stroke.

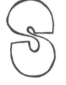

| Thin | Thick | Long | Short |

Changing the centre of the letter.

| Equally wide | Varying width | Wider in one dimension |

Changing the width of the letter.

| Varying | Fat on top | Fat at bottom |

Changing how the letter's 'mass' is spread.

Stretched top and bottom

Equally stretched all over

Changing the height of certain elements.

[Exercise] Fitting letters together

Complete the alphabet by fitting the missing letters into the gaps.
Think carefully before starting each letter and try not to leave wide spaces.

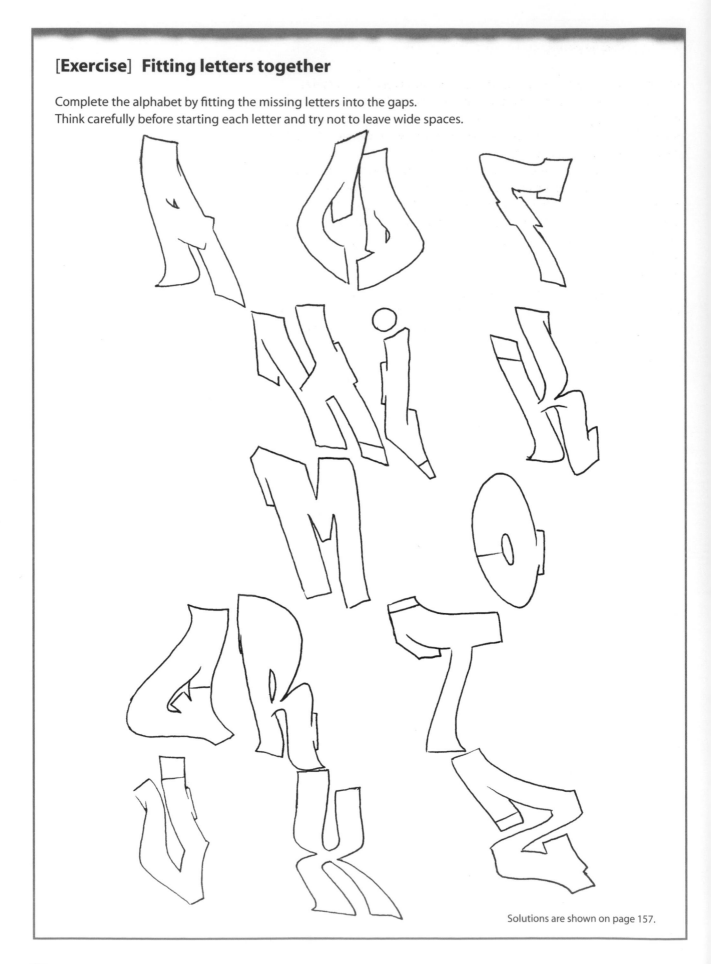

Solutions are shown on page 157.

Style ABC

It's clear that the outer shape of most letters allows for almost limitless variations in design. Add to this the additional style elements such as connections, swings or arrows used to combine letters and you'll start to see just how easy it is to create your own graffiti style. Even if it isn't elaborate, it can still have a unique touch.

It is important to remember that there are some letter structures that offer fewer possibilities: when designing the letter I you certainly have fewer options than you would have when working with the letter S. An I is just a straight vertical line (with perhaps serifs or a dot at the top). No horizontal line can reach out to the next letter; if it has too much swing, it becomes an S; if the serif at the top is too big, it becomes a T – and so on. Nevertheless, options remain for designing or connecting an I – you just need to be creative.

Don't worry too much about what you can't do; instead, concentrate on the letters that give the greatest number of possibilities for connections. To help you, here are some of the most important style elements and effects used to join or space out combinations of letters.

[1] Connections

[2] Grown-together

[3] Swings, arrows and distance

[4] Fragments and dividing lines

[5] Straight lines only

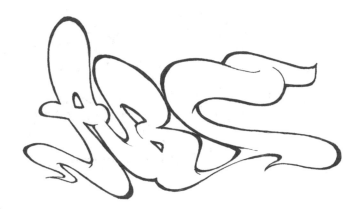

[6] No straight lines

[7] Drips

[8] Omissions

[9] Figurative elements

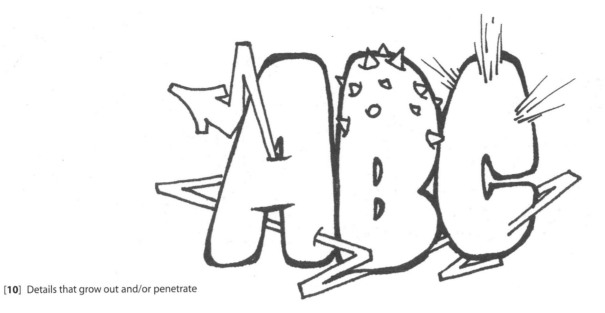

[**10**] Details that grow out and/or penetrate

[**11**] Imitated textures

[**12**] Balanced

[**13**] Parallel lines

[**14**] Shattered

[15] Dissolving

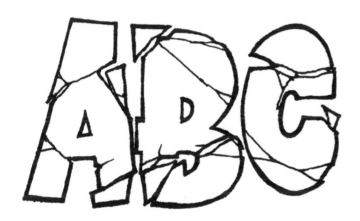

[16] Broken

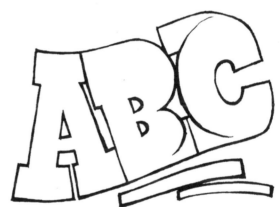

[17] Undulating

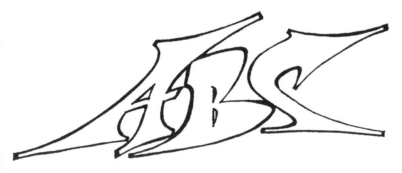

[18] Accentuated serifs

[19] Negative space within the planks

The world of styles

Some complicated styles can change the design of a letter completely.
They have their own rules and are based on a certain effect or look.
Here are some of these special examples.

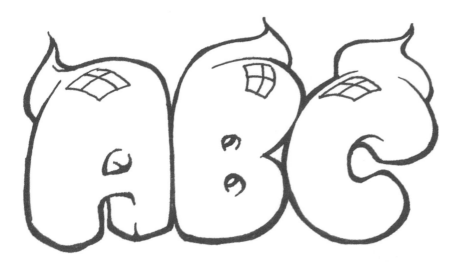

3D styles play with space, perspective, colour and shading to create the effect of depth. In sophisticated examples (such as [**3**]), blocks and letters fit together in ways that suggest multiple viewpoints.

[**1**] 3D bubblestyle with a window-reflection effect.

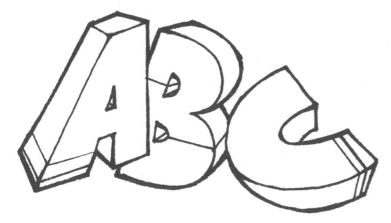

[**2**] 3D blockbuster with parallel lines and dividing lines.

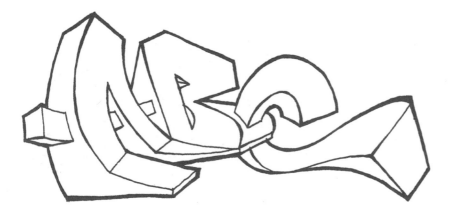

[**3**] Complex 3D style with twists and connections.

[4] Organic matter

Tip Omit straight lines and keep the key areas simple.

[5] Cloud-like bubblestyle

[6] Goldbar

The famous goldbar style uses lines running inwards from every corner of the outline. These lines are connected parallel to the outer shape, forming a smaller version of the outline on the letter itself. Goldbar style makes letters appear to become thicker towards the back, much like ingots.

Tip When creating a goldbar effect, draw a short, thin line from the middle of every angle created by the outline and connect them. Your original letters should be thick enough to allow any key areas within the letter to be outlined.

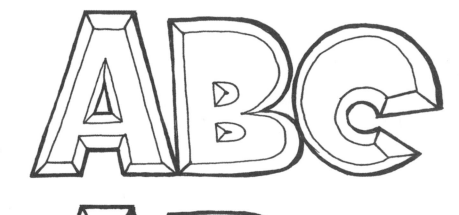

[7] Goldbar with areas shaded black

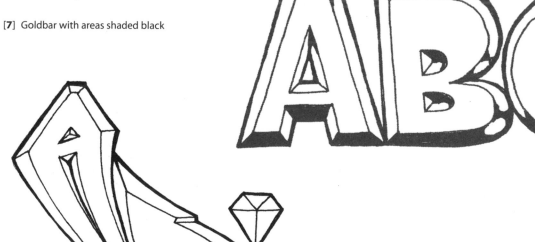

[8] Melting goldbar with diamond decoration

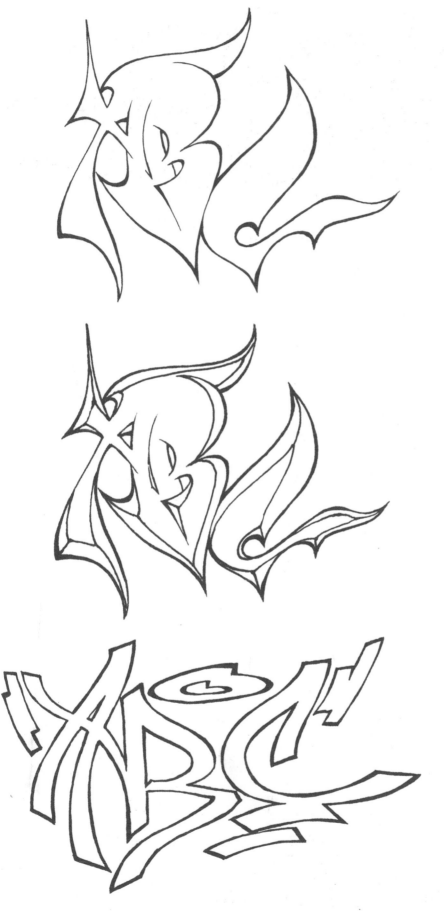

[9] Heavy metal

This letter style relies on pointed corners and blade-like forms to appear medieval and dangerous. It is probably for these reason that heavy metal and gothic rock bands often use the style to illustrate their band's name and merchandise.

[10] Heavy metal with blade points

This alternative version uses additional lines (a little like those of goldbar style) on the inside to give the appearance of sharper edges on the blades.

[11] Calligraphy Style

Calligraphy-style tags imitate text written with a broad-tipped pen. This means that the outlines of each element are always parallel, and the width of the planks and curves varies according to the direction of the line only.

[12] Paperstyle

Paperstyle letters are designed as
unrolled, folded or flying paper strips.

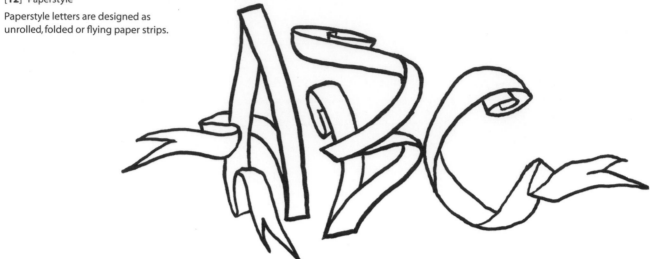

[13] Overlapping outlines

[14] Adjoining

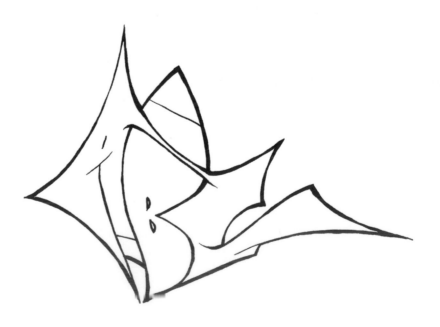

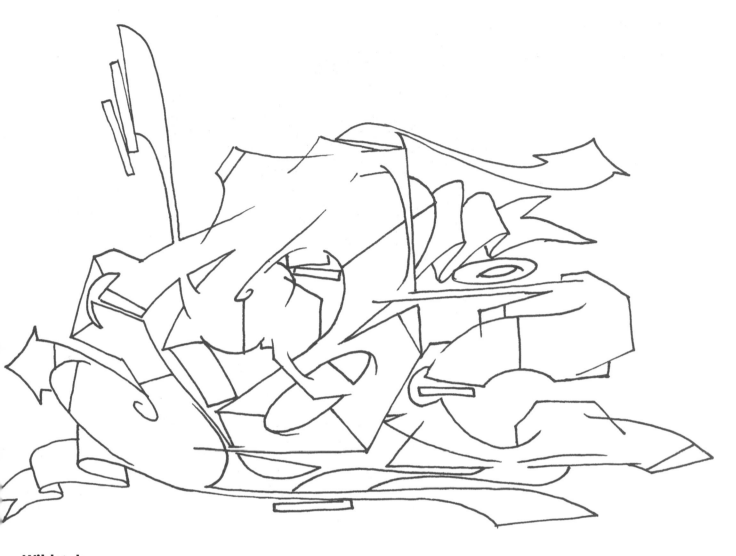

Wildstyle

[**15**] Classic wildstyle

Wildstyles are highly complicated, contorted, broken and connected letters, often featuring a number of additional elements. The term is generally used for any wild or hard-to-read graffiti style.

Nowadays, extreme wildstyles that appear to be nothing more than a huddle of letter fragments and confused elements have become quite rare because they do not live up to what modern writers consider to be good style. Even for experienced writers, some wildstyles are hard to decipher, and the flood of additional elements can actually be distracting, taking away from the shape and energy the letters would otherwise have.

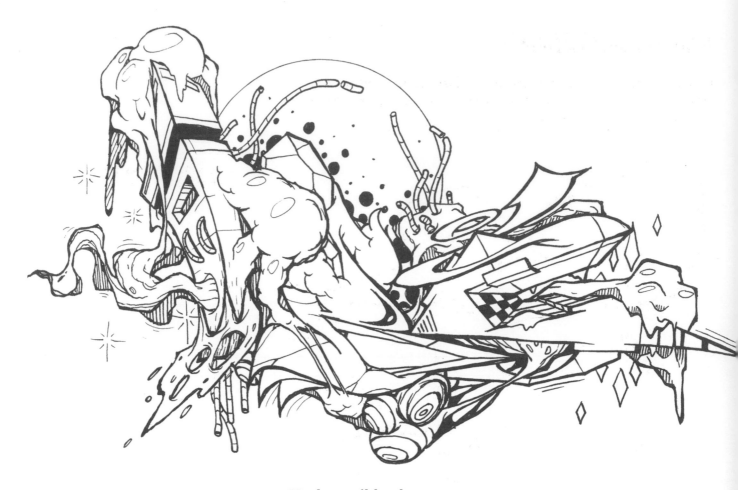

[16] Modern wildstyle

Modern wildstyle

Modern wildstyles work with conventional letter structures, which are reinterpreted to feature extensive complexity and ornamentation. Often the letters melt and connect with the various (highly detailed) background layers, which in this way become focal parts of the piece. These different textures and patterns combined with style elements such as overlaps and connections help generate the complexity of modern wildstyles.

This new interpretation of wildstyle is demanding both in terms of technique and composition, as well as being very time consuming. More common are so-called 'semi-wildstyles', which are less elaborate and so easier to decipher.

[17] Semi-wildstyle

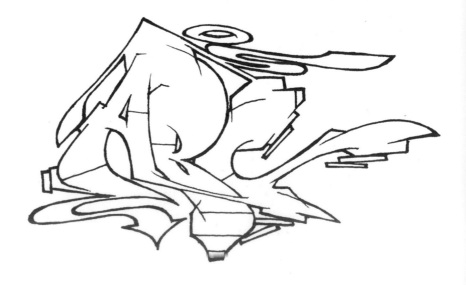

Appearance and look

Letters can express and communicate certain characteristics and moods. Different techniques, lines and designs allow graffiti pieces to have specific emotional effects on the viewer.

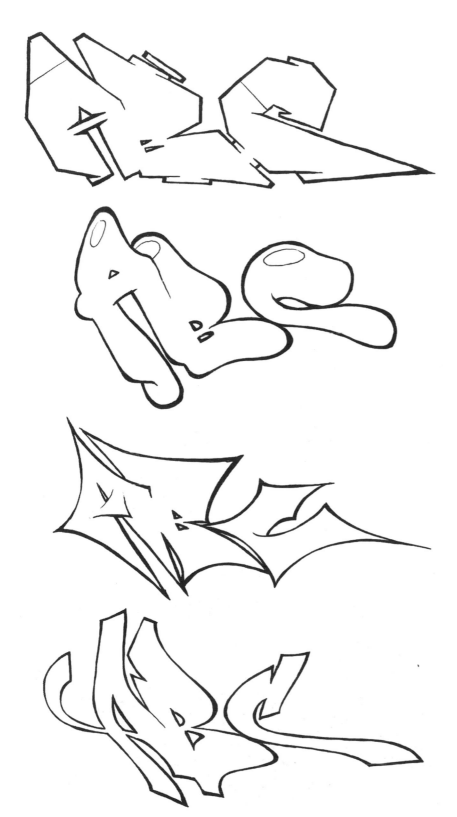

Straight lines and lots of angles make a piece look hard, mechanical and futuristic.

Round shapes make a piece seem soft and dynamic.

Pointed corners and sharp edges give graffiti a dangerous and aggressive impression.

Long swings make writing look elegant and classy.

Style elements

Frequently decorations and elements that do not belong to the letters are added in order to make a piece bigger, more detailed or simply more interesting. Arrows and swings are used especially often. A variety of shapes and forms fit with every letter style – here are some of the most important.

Arrows

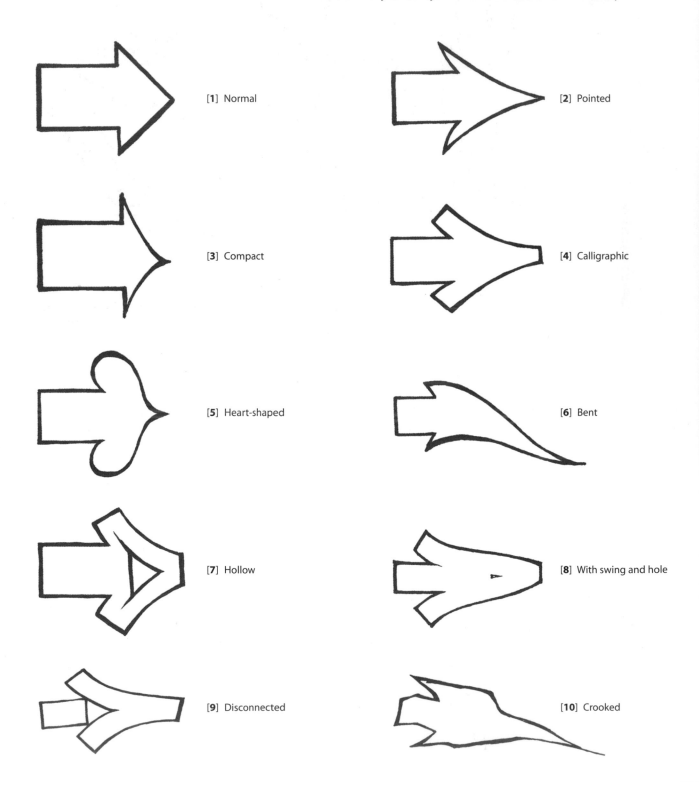

[1] Normal

[2] Pointed

[3] Compact

[4] Calligraphic

[5] Heart-shaped

[6] Bent

[7] Hollow

[8] With swing and hole

[9] Disconnected

[10] Crooked

Bits and pieces

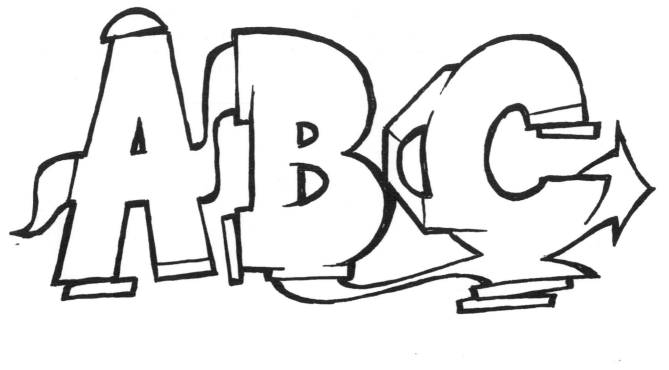

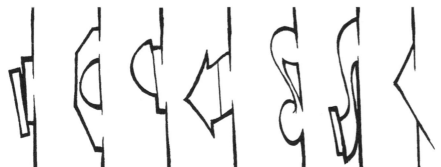

Long lines can be broken up with additional elements. Doing this not only fills up free space, but the piece also becomes larger and more complicated.

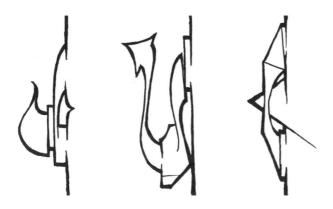

Ornamental designs can be expanded, combined and refined.

Style additions

The following elements can be attached to letters to decorate them or to give a more expressive impression overall.

[1] Simple swing

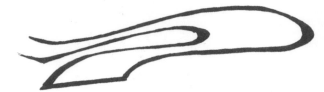

[2] Returning swing

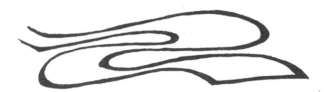

[3] Double swing

[4] Bubble swing with pointed tip

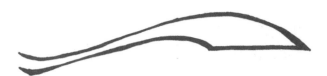

[5] Loop (with a broken tip)

[6] Rounded roll

[7] Angular roll

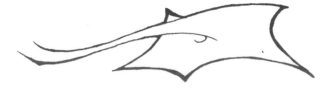

[8] Spiked roll

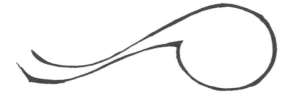

[**9**] Closed roll

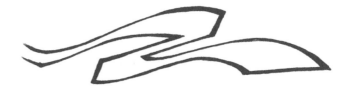

[**10**] Double calligraphy swing

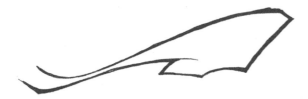

[**11**] Downwards hook

[**12**] Rectangular serif

[**13**] Sting

[**14**] Upwards hook

[**15**] Overlapping outlines

[**16**] Grouped arrows

The shapes and proportions of these style additions can be altered and mixed. Here are some combinations made using the basic styles seen so far.

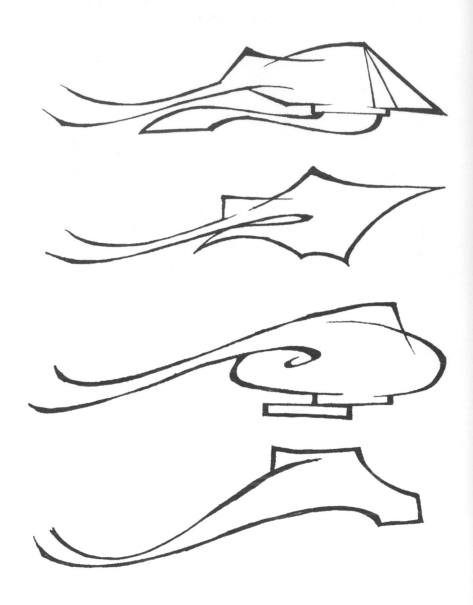

Style stars

Most stars (except for the irregular) are sketched with one line and then filled.

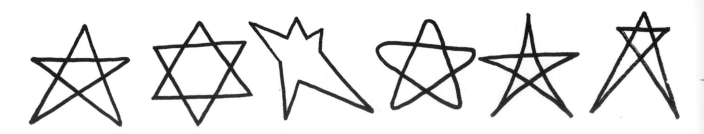

five-pointed six-pointed irregular rounded sharp stretched

Style samples

So far this chapter has dealt with the variety of style elements and options available to graffiti writers. When combined, they can be used to create complex graffiti styles. Here are some examples.

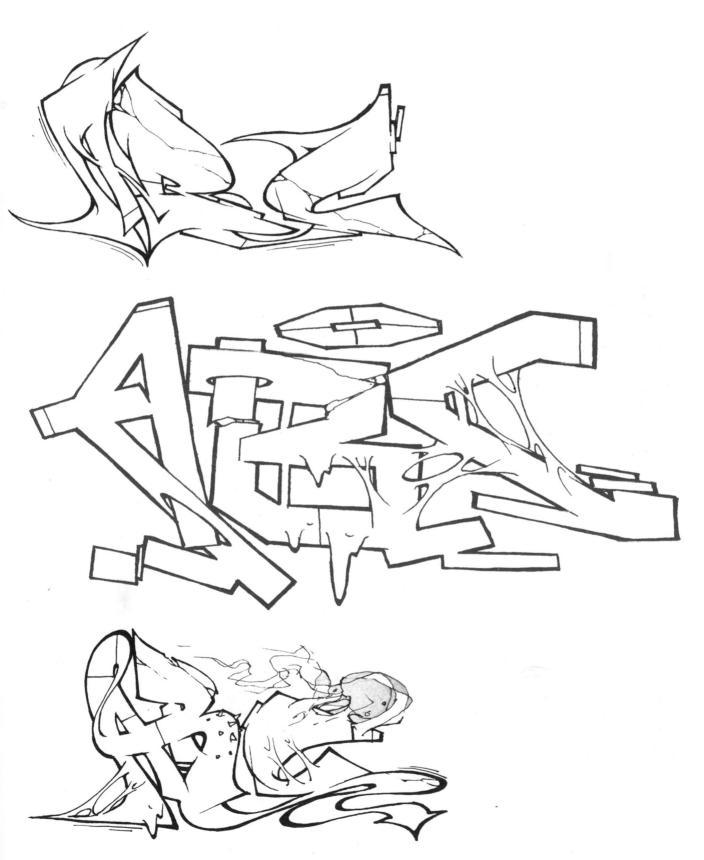

3D blocks and shadows

Shadows and 3D blocks help a piece to stand out by providing dimension and depth. 3D blocks make a piece look more concrete and massive, while giving writing a shadow makes it seem like it is floating in front of a background.

3D blocks

There are two main variants of 3D blocks.

[1] **Parallel blocks** This style makes the letters seem to stand out a short distance from the background. How's it done? [A] Draw equally long parallel lines from every corner and meeting point of the word's outline. Make sure your lines appear to stay 'behind' the letters. [B] Then join up the equally long lines, remembering to make sure the line that joins them stays parallel with the outline of the word.

[A]

[B]

[2] Vanishing point This variant of the 3D block style uses a vanishing point instead of parallel lines. This makes the letters look so deep that they extend out of sight. How's it done? Select a vanishing point – this can be directly behind the word or somewhere else on the wall. Next draw lines from every corner, edge or connection on the word towards the carefully marked vanishing point. Start with the outer lines and remember to keep the lines 'behind' the letters.

Often a lack of space means that 3D blocks with a vanishing point are cut, as in the example below.

When writing pieces on small surfaces it's often a good idea to select a vanishing point that is behind the word. This means that no additional space is needed, either to the sides or at the top or bottom.

Shadows

In this popular effect, the piece appears to be casting a shadow on a background – this makes the text look more concrete, as well as helping the letters look sharp against the darker background. How's it done?
[**A**] Decide what direction the light is hitting the letters from and move the outline of the piece the opposite way to form a silhouette. Start by making sure you get the prominent and distinctive points of the outline an equal distance from the original word.

[**B**] Connect these points by matching the original outline and fill the shadow in with a darker colour. The further you move your silhouette from the piece, the further your letters will seem to be from the background.

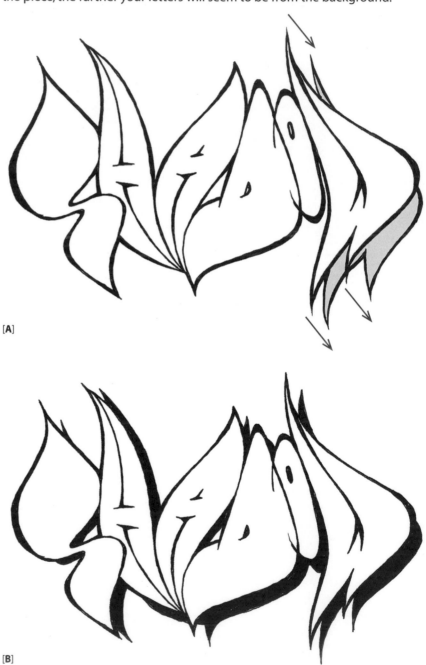

[A]

[B]

Combinations and variations

Shadows and 3D blocks can be combined.
Here are some examples of how.

[**1**] A 3D block with a hard shadow.

[**2**] A fade effect that mimics spray paint
produced using small dots.

[**3**] A hard ground shadow. This effect makes
it seem as if the letters are sitting on the
ground with the sun directly overhead.

[**4**] A shadow with 3D blocks.

[Exercise] 3D blocks

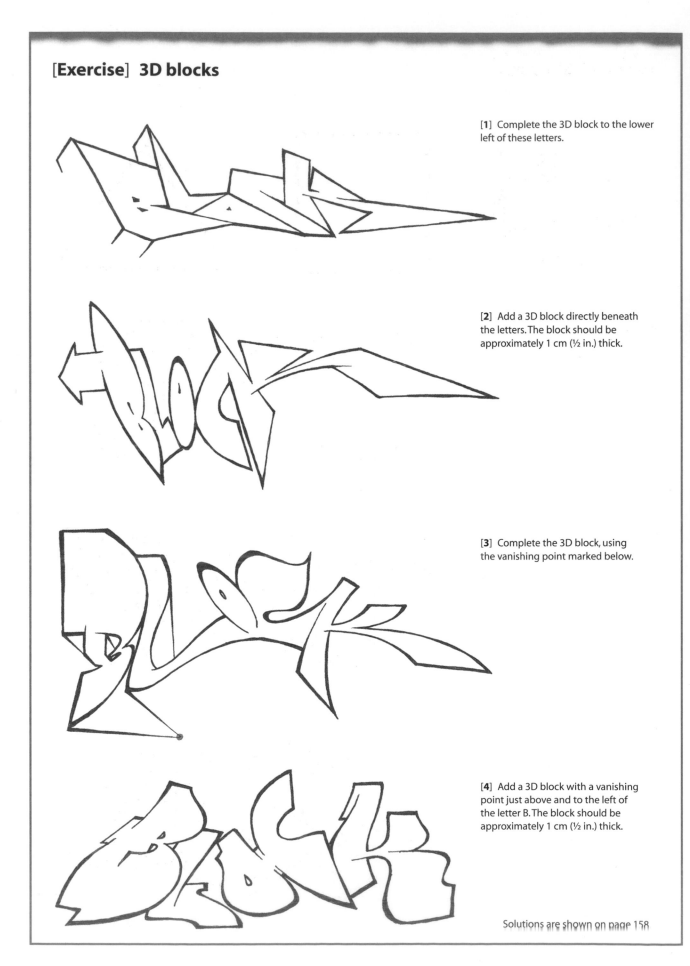

[1] Complete the 3D block to the lower left of these letters.

[2] Add a 3D block directly beneath the letters. The block should be approximately 1 cm (½ in.) thick.

[3] Complete the 3D block, using the vanishing point marked below.

[4] Add a 3D block with a vanishing point just above and to the left of the letter B. The block should be approximately 1 cm (½ in.) thick.

Solutions are shown on page 158

[Exercise] Shadows

[**1**] Draw the shadows of these geometrical shapes as if light is arriving from the upper left, as in the example above.

[**2**] Complete this word's shadow, again imagining that the light is arriving from the upper left.

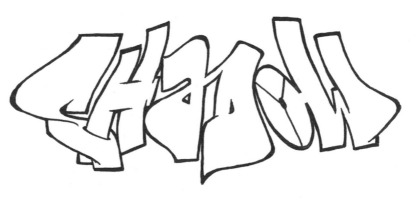

[**3**] Add a shadow to the piece, imagining the light is arriving from the upper left.

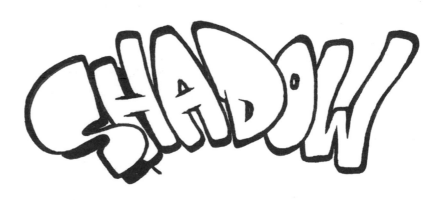

Solutions are shown on page 159.

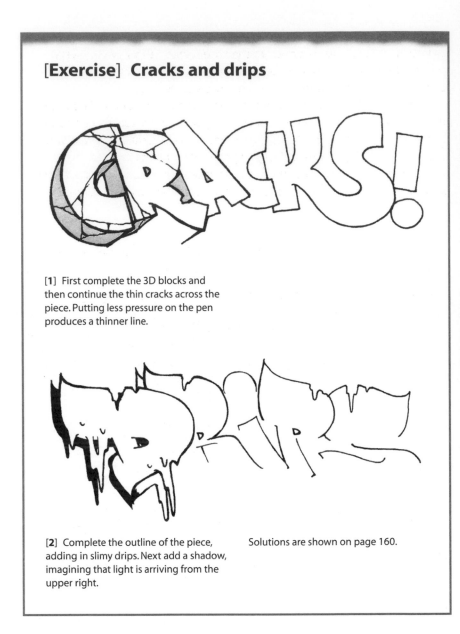

[Exercise] Cracks and drips

[1] First complete the 3D blocks and then continue the thin cracks across the piece. Putting less pressure on the pen produces a thinner line.

[2] Complete the outline of the piece, adding in slimy drips. Next add a shadow, imagining that light is arriving from the upper right.

Solutions are shown on page 160.

Backgrounds

A good graffiti style should look great without any background. Nevertheless, almost every graffiti writer will choose to add some form of background to his or her piece. There are good reasons for doing this, both practical and stylistic.

Firstly, backgrounds can be included to fill in gaps between the letters. Secondly, most surfaces that graffiti is sprayed on are not blank prior to being painted; often they already have old lines and colours on them. If not painted over, these lines and colours distract the viewer and can ruin the overall look of the new artwork. A stylistic reason to include a background is the opportunity it provides to make the letters 'pop' (appear more clearly defined to the viewer). Choosing a background colour with a high contrast to the letter outlines helps this effect. See the colour wheel on page 88 to find the contrasts that work best. Backgrounds can also cover extra space and make the piece larger, or even change the overall shape of the writing.

Graphic patterns and shapes such as clouds, flames and spikes are most often used to decorate a piece and fill in empty areas. When several different

background elements are used, they are normally organized in layers around the letters. The first layer is closest to the letters, with the following layers arranged behind it. Often these outer layers are decorated with additional patterns or outlines in order to give structure and depth.

Some graffiti backgrounds are artworks in their own right, while others interact closely with the letters to become a part of the actual piece. Learning to produce highly complicated backgrounds is a very creative process and takes just as much practice as designing the letters themselves.

Simply by using lines, countless background patterns can be created – here we will focus on some of the most popular and basic background elements.

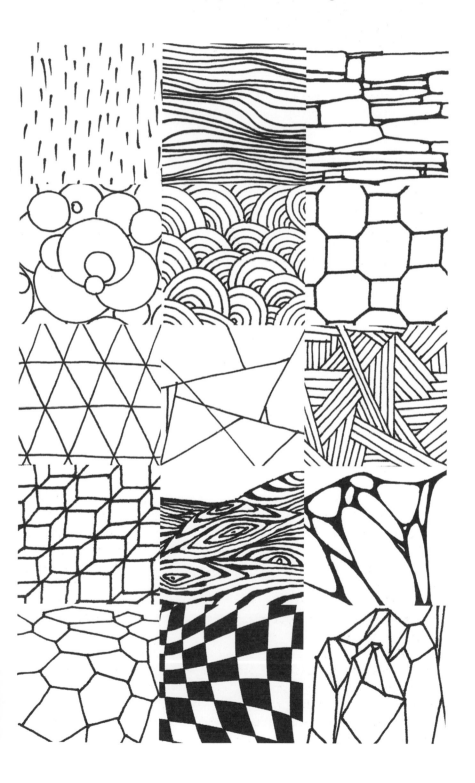

Various background effects, from wood to goo, and from chessboard to diamond.

One basic way of allowing letters to interact with their background is nestling them in clouds. Sections of the cloud overlap the outline of the letters and the background becomes part of the piece.

Another common effect is snow, which is drawn settled on the letters and covering up some parts of the piece. This gives the piece a 3D look while also integrating the letters and the background.

A waving banner or a similar object can wind through and around the letters, filling empty space between letters and helping to create dynamic lettering.

More elaborate pieces may incorporate additional background layers that mingle and overlap one another.

Characters

The decorative graffiti cartoons that are sometimes painted alongside, over or even inside letters are called characters. A wide variety of these figures are used, with animated characters, animals, monsters and beautiful women being among the most popular.

Choosing a well-known cartoon from popular culture that has simple proportions, fewer details and a limited palette of colours will be easiest to learn. Choosing an uncomplicated image allows for easy simplification and abstraction. What's more, examples of the original cartoon will not be hard to find; however, if you pick a well-known and easily recognized example, then it will be easy for viewers to spot mistakes and departures from the original.

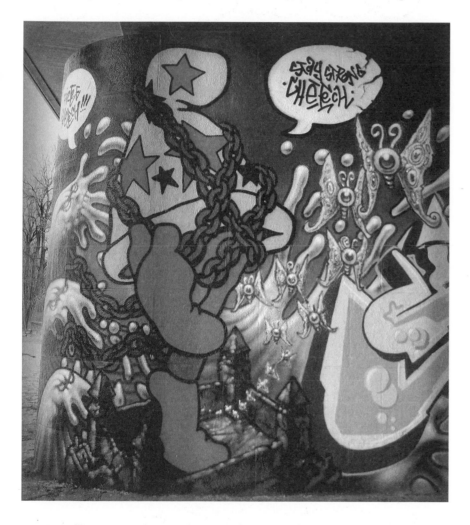

A graffiti cartoon drawn relatively often is 'Cheech Wizard'. The character (seen above, in chains) was originally created in the 1970s by Vaughn Bode. Disney and Marvel characters have proved some of the most popular among graffiti writers.

Copying characters is usually accepted because such cartoons serve only as ornamentation to the letters – the actual artwork. Sprayers not content with merely copying characters must start designing their own.

If characters become the main focus of a graffiti artist's work, then the pressure of coming up with original figures (rather than biting well-known examples) also increases.

B-boy characters

The most ubiquitous graffiti character is without doubt the b-boy. His style can vary from realistic to cartoon-like to abstract, but the facial features remain simple and typically minimal, with either simple shading or no shading at all. The main characteristic is a cool stance but accessories such as hats, chains, glasses and beards are often also added. Just as with letters, an outline that varies from thick to thin gives the character a lively appearance.

When colouring characters, shading can be done with hard lines (below left) or with fades (below right) for a more realistic effect.

Rat, superhero and beautiful lady characters sprayed by Eazy. Writers with many years of experience, such as Eazy, are able to design their own characters freestyle at the wall.

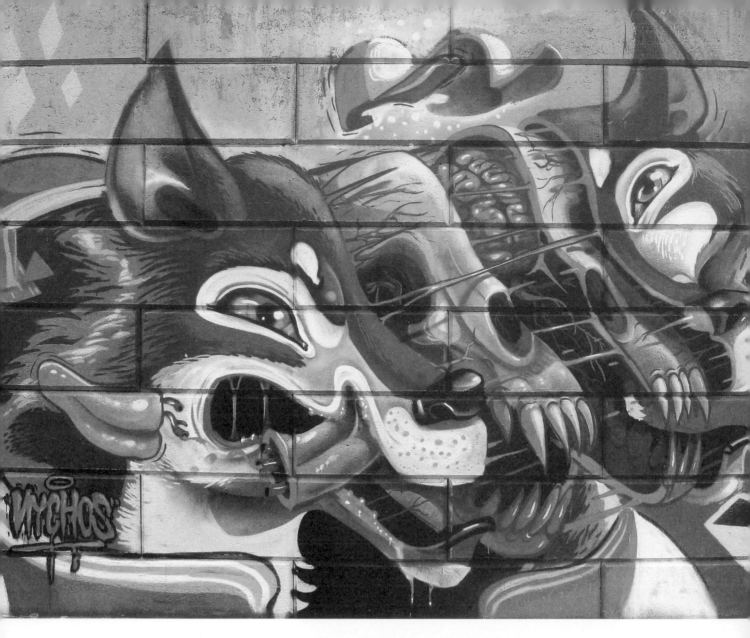

[**Above**] Wolf character by Nychos

[**Right**] Law One is living dangerously …

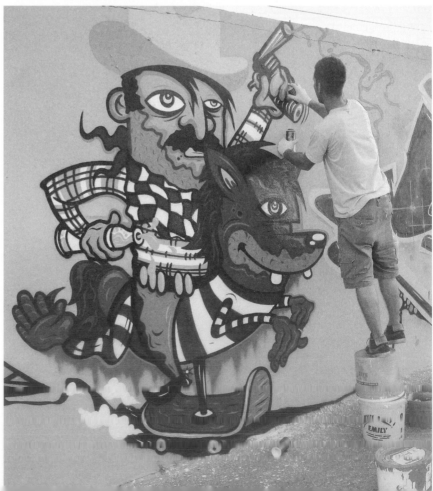

Colouring

As well as the shape and style of letters, it's colour that gives personality
and life to a graffiti piece. Main areas (such as the fill-in, 3D blocks and the
background) are rarely filled with a single colour; often a mixture of pigments
and shadings will be used. Knowing how to combine a variety of different
colours is one of the key skills you will need in order to fill in letters well.

There are two principal ways of putting paints alongside one another:
soft fades and hard edges. These two skills can be modified and combined,
meaning that there will always be a number of ways to merge (even
contrasting) colours. You can find some of them on pages 109–12.

When practising or preparing pieces on paper fewer effects can be
achieved than when using the spray can out at a wall. Fades are very hard
to do and, since most inks are not opaque, going over darker areas with a
lighter-coloured pen is pointless. In short, it's important to remember that the
technique of colouring on paper is completely different from painting with a
spray can. Despite this, it's still important to know the techniques in case you
need to sketch a piece out to check different colours and effects can work
well together.

Although it's not as easy to achieve and never as perfect as when done
with a spray can, fades can still be done with pens. By choosing similar yet
slightly different colours, arranging them from darker to lighter and altering
the pressure on the tip it is possible to achieve fade-like effects. Almost-empty
and dried-up pens can be very useful for this.

Even though the techniques are entirely different, the purpose of
colouring – whether with pen or with spray – is the same: to generate
contrasts and to create depth.

The use of contrasts

Finding a strong colour scheme relies on knowing how to create and work with eye-catching contrasts. The letters are supposed to be clearly visible, so choosing colours for the outline and fill-in that differ strongly is vital. The outline should also contrast with the background, and so on.

Altogether, there are three different categories of contrast:

[1] **Bright–dark** This is the strongest form of contrast. For this reason, most pieces will use black and white somewhere in their outline, even when other options are available.

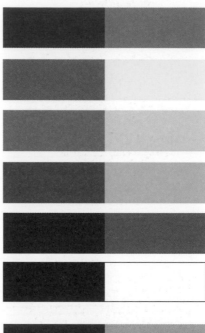

[2] **Pastel–fulltone** The effect is achieved using the combination of a strong and a weak shade of the same colour. Although less prominent than the bright–dark contrast, pastel–fulltone contrasts can make a piece look harmonic, realistic, calm and consistent.

[3] **Warm–cold** Warm–cold colour combinations, such as blue outlines around yellow, are clearly visible, while a red–orange combination is harder to see. Maximum contrasts are achieved by combining colours from opposite sides of the colour wheel, right. This is an excellent resource for beginners still forming their own preferences and colour schemes.

Generating depth and shape

Bright and dark shades of the same colour can be used to create the effect of depth – while white highlights and reflections intensify the impression that a shape is 3D. The following images show how a flat circle is transformed into a round ball through the addition of darker and lighter colours.

There are a few other considerations to bear in mind when generating a convincing 3D effect, such as that the 'rounded' surface of the ball now alters the shadows that fall across it. While a shadow crossing a flat '2D' circle remains straight, it will appear bent over a ball.

This method of creating a 3D effect using shades of the same colour can easily be transferred to letters. If a letter is shaded from one side and highlighted from the other, such as on the ABC below, a similar effect is produced.

[1]

[2]

[3]

It is also possible to achieve a 3D effect by using hard edges instead of fades [1]. This look can be described as clear and graphic, while faded effects [2] make a piece look more realistic. A more advanced version of suggesting 3D form is achieved by putting a faded glow on the dark side of the piece [3], which suggests another colour or light source is shining on it. This last effect can produce a gloomy atmosphere.

These 3D styles are perfect examples of ways in which colour can create a sense of form and shape. Light and darkness emphasize the letters: sharp edges are highlighted with hard lines while smoother areas are highlighted with soft fades. If colour is used consistently and with high enough contrasts, even drawing the letter's outline becomes unnecessary. It can be replaced by the contrast of reflections and shadows on the letters, helping them to look even more 3D.

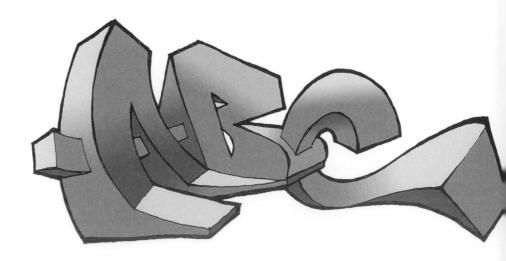

Tips for colouring

- Use the entire colour spectrum, not just the basic tones.
- Use minimal contrasts (e.g. use shades of just one colour) to give your piece an elaborate and natural look.
- Most neon and fluorescent colours don't cover well and aren't suitable for fill-ins.
- Do not exclusively use bright colours. It is a good idea to mix in some dull colours like grey or beige to bring out strong and shiny colours.
- Use a short strip of a 'buffer' colour (such as white, black, grey or beige) when you want to connect two strongly contrasting colours.
- Likewise, similar colours that do not look good next to each other can be joined by a neutral buffer colour.

Finding your own style

Graffiti is fundamentally a craft. Its key skills of creating and composing letter shapes, and then applying existing styles, well-established designs and traditional colouring can all be learned. These techniques could all be described as aesthetic but perhaps are not quite artistic. They are the foundations.

A perfect technique and adherence to the rules of style will get you only so far. An exact copy of an pre-existing style is not considered acceptable within the graffiti art scene. Attaining an individual style is the priority. The raw ingredients for your 'own' style are easily found on the internet or in magazines. These sources offer everything a good style needs, and the greatest cost is the time spent studying examples and working on ways of incorporating them into your own work. Once something new and fresh emerges from the graffiti you've studied, your own writing can be called art. It is only then that a writer can claim to have found his or her own distinctive and individual style, which is – or should be – the aim of every graffiti artist. The strongest evidence that a style has become original is for another graffiti writer to recognize the piece as the work of a particular artist without even reading the letters.

Of course, it is not expected that every writer will invent entirely new letter forms and techniques. The creativity that a good writer is expected to exhibit exists mainly within the ability to neatly and cleverly combine the individual elements he or she has taken from other pieces. Often these elements can be built into one's own style only after adjustments and modifications are carried out. A style master is someone who succeeds in altering, integrating and synthesizing elements so that a coherent and characteristic style is created.

The 'rules' and exercises outlined in this book are there to help you learn to draw logical and legible letters, and can be considered the foundation of a writer´s style development. Once understood, particular rules can be broken or reinterpreted as the artist develops and begins to want to achieve a certain effect, or perhaps simply feels that breaking a rule adds to the look of a piece.

At that stage of development, every writer has to find out for him- or herself which features best suit their own style, how to implement them and most importantly – and subjectively – what can be considered an aesthetic improvement. Solid technical skills can be learned from painting, but bringing them together in a good style is something that develops throughout a writer's lifetime.

[4] Spraying graffiti

Transferring a sketch from a sheet of paper to the wall is tricky: retaining the correct proportions and angles as you expand the design to fit the larger format will be a test for anyone starting out in graffiti.

Good technique begins with a steady hand and a sense of timing – and these come from practice. It's worth taking individual elements (such as straight lines over 1 m [3 ft] in length) out of an overall design and repeating them until you're confident. Lastly, you won't get proper results unless you are using the proper materials.

But don't forget that working with a spray can is a special experience, and one that allows you to achieve unique results: large areas can be filled quickly, evenly and without needing to dip a brush repeatedly into paint. Spray cans mean that even rough surfaces can be painted easily and swiftly. Sprayed paint has its own unrivalled effects too: soft fades are easy to achieve, as are perfect edges and highlights and reflections.

This chapter contains an introduction to the materials, the most important techniques, design examples and explains the different stages of a graffiti piece.

Tools

Spray cans are pressurized containers that vaporize paint through a nozzle. Since the mid-90s the tool and the paint have both been improved immensely by the manufacturing companies, who have adjusted the product to meet the needs of graffiti artists. Manufacturers now sell an extensive colour range of spray paints that, due to the increased quantity of pigment and the optimized propellant, are very quick drying. This means that drying intervals are almost non-existent and further work can be continued without needing to wait.

The coverage of spray cans has also improved. While the first generation of graffiti writers had to work exclusively with cans from hardware stores (which meant applying at least two coats for an even finish), spray cans nowadays generally give instant cover. The soft spring in the valve of modern cans guarantees a responsive cap and so a well-regulated flow. The paint in a 400 ml [14 fl. oz] can of spray usually covers 2–3 m² [22–32 ft²] depending on the shade (yellow and orange sometimes need a thicker application) and on the surface that's being sprayed.

In the 1980s and early 90s, teenagers who wanted to spray graffiti had to buy expensive cans of low-quality paint in great quantities, which led to many oldschool writers racking (stealing) their paints. Today the price of spray cans is comparatively low, which allows even teenagers to finance their hobby legitimately. In any case, the most sought-after spray cans sold in Hip Hop shops and special graffiti stores are these days kept safely behind the counter.

Spray cans are categorized into high-pressure and low-pressure varieties, and each has specific spray characteristics. High-pressure cans release a lot of paint and give a thick line, which is good for fast filling and broad outlines. On the other hand, low-pressure cans allow for more precise and exact handling because of their smaller paint output and the thinner lines produced.

Inside the pressurized can, the propellant is stored in liquid form. The gas that expels the paint is the vapour of liquid propellant (which has a boiling point slightly lower than room temperature). The vapour exists in equilibrium with the liquid at a pressure that is higher than atmospheric pressure (i.e. able to expel the paint), but not dangerously high. As the gas escapes, it is immediately replaced by evaporating liquid propellant.

The most common brands are Montana, Belton Molotow, Ironlak, MTN, Clash, Beat and Kobra.

Producer	Low-pressure brand	High-pressure brand
Montana	Montana Gold	Montana Black
MTN	94er-series	MTN Hardcore
Belton	Belton Molotow	600er series
Colorpack	Beat	Clash
Spraytech	Low Kobra	Kobra

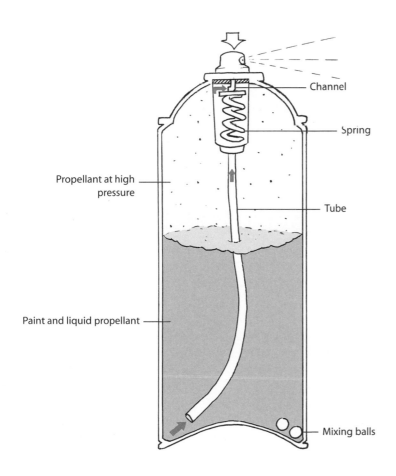

Handling a spray can

Health and safety

The lead-based spray paint used by the older generation was far more dangerous to health than modern paint; however, the vapours in spray paint contain solvents that can be hazardous to health. Drowsiness and dizziness are common symptoms of short-term inhalation, but the long-term effects of sustained use are potentially far more severe.

When working, protective gear is absolutely necessary and should not be neglected. Gloves and a mask (with a filter that cuts out organic vapour) should be worn at all times – furthermore, special care must be taken when painting in badly ventilated places.

Gloves not only keep the hands clean, but also stop solvents entering the bloodstream through the skin. As a general rule, paint should be removed as fast as possible from the skin. If paint gets into an eye, it should be rinsed out with warm water, covered with a sterile pad and you should visit your local emergency department.

The key guidelines are:

– The right mask and gloves will minimize any potential negative effects on your health.
– Take the caps off the cans when you are finished.
– Do not store the cans in your room.
– Do not store your mask together with the cans.

A few light exposures to vapour without protection gear is certainly nothing to worry about. Many beginners even delay the purchase of a gas mask until they are sure that they will continue graffiti writing for a while, which is understandable considering the price of a good gas mask. But it's always worth reading the label whenever you're using paints, solvents or spray cans.

Caps

There are various spray can caps, or nozzles, on the market that have special characteristics, but essentially they all work in the same way. The liquid enamel is vaporized through a nozzle of a certain diameter. This diameter, together with the paint release rate (which depends on the pressure of the can), determines how thick or thin the line of paint will be.

The image below shows how the distance from the wall can affect the strength and width of the line.

The closer the nozzle is held to the wall, the thinner and stronger the spray will be. If the can is held too far away then only paint dust will reach the wall.

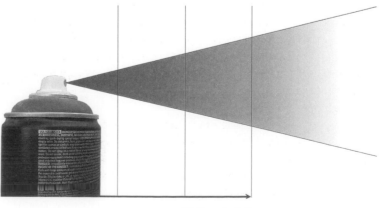

Distance to wall

Different caps

Name	Characteristic
Skinny cap	Releases a little paint within a small diameter, giving thin lines. Useful for outlines.
Banana cap	Releases slightly more paint than a skinny cap. Useful for fill-ins or thicker outlines.
Fat cap	Releases a lot of paint in a large diameter. Useful for fast filling and thick lines.
Soft cap	Releases a small amount of heavily vaporized paint. Useful for soft fades and dust effects.
Standard cap	Releases a lot of paint in a small diameter. Useful for fast outlines. The high pressure can cause a ragged line.

Be warned that not all caps work perfectly with all cans. In some cases paint can be released uncontrollably from the valve, though not through the nozzle in the cap. This unpleasant result is called overkill, and usually causes paint to drip down the can. An irregular fizzing sound indicates the beginning of an overkill, which can normally be stopped simply by pulling off the cap.

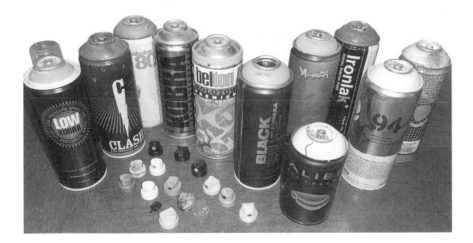

Here are some rules and bits of information worth knowing when using spray cans:

- Shake the can well before you use it. This mixes up the paint and helps build up pressure for fewer blocked caps and an even colour tone.
- When changing a cap always point the valve away from the body.
- If you've finished, you can clear your nozzle of paint by turning the spray can upside down and spraying a small amount of paint after every use. Make sure the can is turned away from people and objects. The tube inside the can is empty when only clear solvents spray out.
- If the paint flow stops but the can is not yet empty, then there is probably a blockage in the cap.
- If the the cap becomes blocked while spraying, it's often enough to pump (shake) the can a few times or switch the cap to a can with higher pressure to clear it.
- If a can has too much pressure you can release the excess by holding the can upside down and spraying spare propellant with a fat cap.

– At lower temperatures cans have lower pressure, altering how much paint is released. Paint also takes longer to dry, which can result in unwanted drips.
– Wind can affect spray direction!

Preparing walls

Good graffiti walls are even, clean and do not soak up much paint. Modern spray will provide good coverage on these surfaces without the need for a base coat. Old walls (especially those with a dirty or mossy surface) soak up the paint before it dries and builds up a covering layer. On walls such as this, colours lose their opacity, luminosity and weather resistance. When working on an old wall, it's best to clean off dirt, any moss or vegetation, and prime the area with a base coat of exterior (weatherproof) paint.

Frequently used legal walls are often primed with cheaper interior paint because the pieces are not expected to last for long. Here a bottom coat is primarily used to give an even background colour, as well as to get rid of any distracting lines left over from previous pieces. With a wide roller and an extension tube, huge areas can be primed within a short space of time. High-quality primer covers old graffiti with one coat, while cheaper paint might need two or even three coats to achieve an even finish.

Spray techniques

With the know-how and tricks contained in this book you'll soon discover that the spray can is an unbeatable medium for tackling large surfaces. The techniques and effects explained over the pages that follow are different from each other in just three ways: the distance between the nozzle and the wall; the angle of the hand and posture of the body; and the speed with which the can is moved.

Technical aids, such as image projectors, masking tape or string (for help drawing circles) are usually not used within the graffiti scene. There are two reasons for this: firstly, these tools are often an additional inconvenience, putting many writers off; secondly, using technical aids is basically an admission from a writer that they cannot complete a piece using their skill alone. In situations where perfect results are required, or graffiti is being carried out on a large scale, the use of technical aids is considered legitimate. However, it's important not to come to rely on technical aids; working freehand is less tiresome, faster and much more fun.

Here are the most important techniques for getting astonishing results from freehand work.

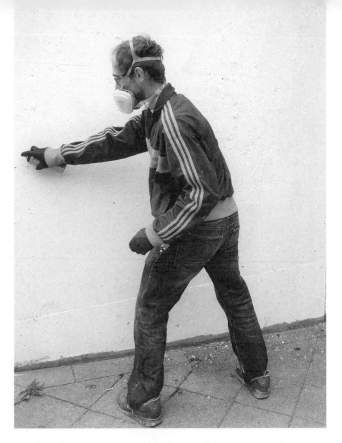

Pulling lines In order to draw clean lines of consistent thickness, you have to move the can at a constant speed at an even distance from the wall. Start moving the can before pressing the cap rather than after as this will help to avoid drips of excess paint forming. Stay relaxed, and when drawing long lines and round swings move your upper body with the can.

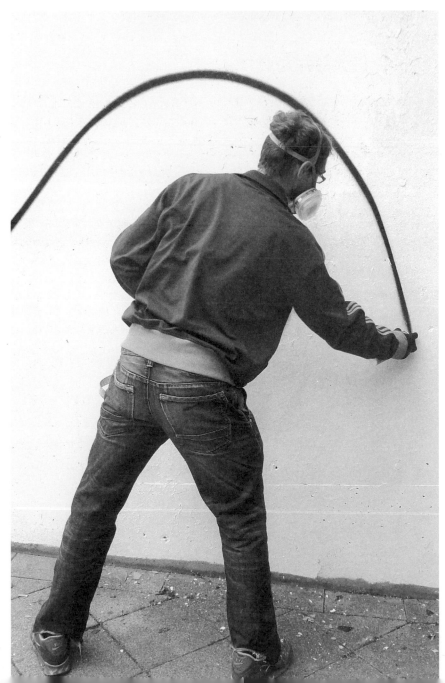

97

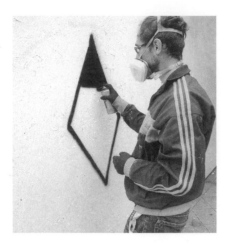

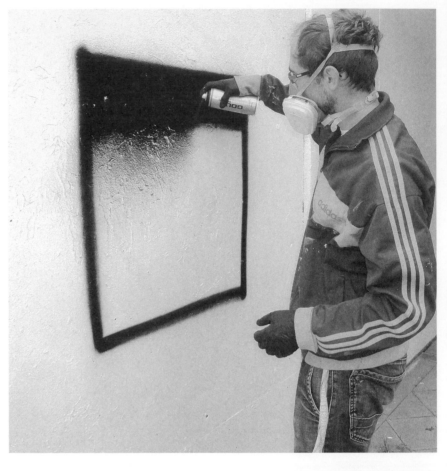

Filling (above) Before you start filling, mark out the area you want to paint. The most effective way of painting a space is to move the can in parallel lines, spraying from a distance of 5–30 cm (2–15 in.), depending on pressure, cap and paint quality. Circular or jerking movements are not suitable.

Fading (right) To create a fading effect, keep the nozzle at an angle to the wall. The cap needs to be held close to the wall and moved slowly, giving the paint time to accumulate thickly on the surface near the nozzle and less thickly further away. This creates a soft fade in the direction of the spray.

Dusting (right) If the can is held far enough away from the wall, only a fine dusting of paint will reach the surface. This effect is often used to create a translucent, foggy or blurry look. It can also give the appearance of background light.

By combining the techniques shown here, any motif or effect can be created. Even simple blockbuster letters can become amazing eye-catchers with a little elaboration.

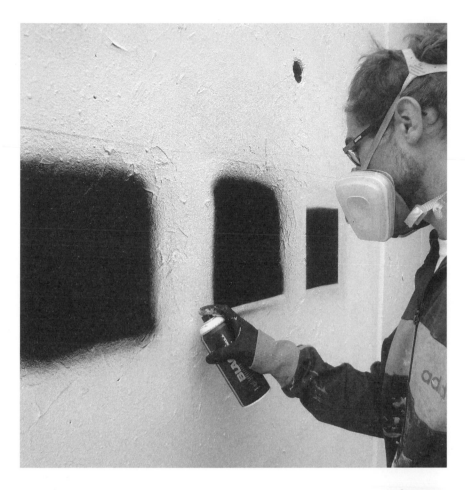

Cutting (left) In order to create hard edges or pointed angles, shapes with ragged edges can be 'cut' into the desired form using the background colour.

Scratching (above) To spray very thin lines hold the can forwards at an angle, this minimizes the distance between nozzle and wall. Scratching is a technique often used for fine details or highlights. The can has to be moved very quickly to prevent drips.

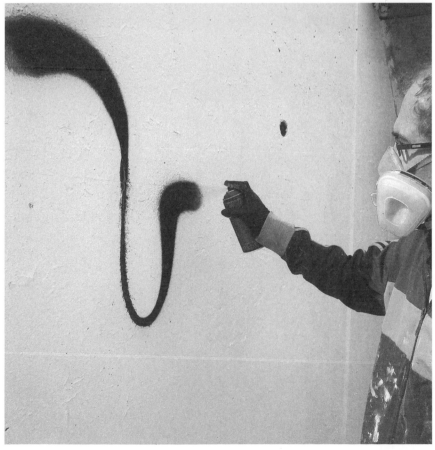

Varying the distance (left) To vary the thickness of the line, the distance from the nozzle to the wall is altered while spraying. This effect is used mainly with outlines and tags.

Varying the angle (above) The angle between the nozzle and the wall can be changed while the can is still spraying. If the nozzle is turned away from the wall at the end of a stroke, then the clear-cut line will seem to fade softly and spread out. This interesting effect can be used on tags.

A burner in six steps

Since graffiti is built up out of overlapping layers of colour, the step-by-step process is very different from working on other media, such as paper.

These pages show the development of a full-colour piece built up out of six layers, or levels. Getting the order of the steps right is important for achieving a clean (and quick!) result.

Before starting a full-colour piece yourself, remember to prime the wall with a tinted, weatherproof acrylic paint.

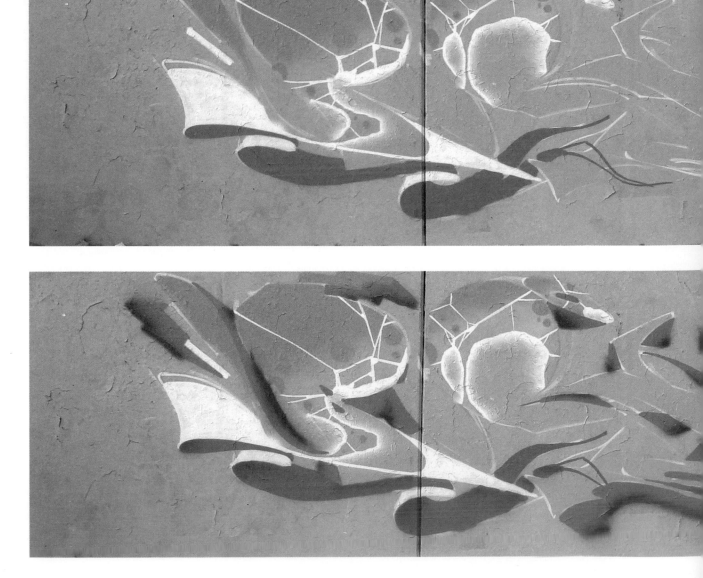

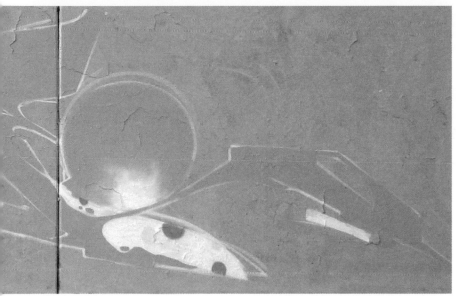

[1] Sketch-up The sketch is marked up on the wall, drawn either from memory (freestyle) or from a reference sketch on paper.

Tip The first letter you draw decides how large the entire piece will become. Regularly take a few steps back to check that the size is correct. Drawing your sketch-up with a colour similar to the background means later on you can correct it with a stronger colour.

[2] Fill-in The letters are being filled.

Tip Cover up the lines of the sketch almost completely with your fill so that you can spray over the edge with the outline later.

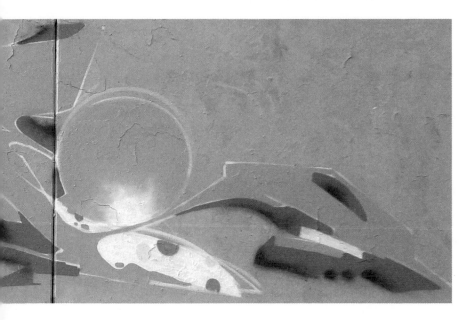

[3] 3D blocks The 3D blocking around the edges of letters is marked up and filled in.

[4] **Background layers** The background layers are added to make the overall piece more eye-catching. You can also add images or effects that relate to the word being written.

Tip Surround your piece with an interesting background shape. It doesn't have to be a square and it doesn't need to go all around your letters.

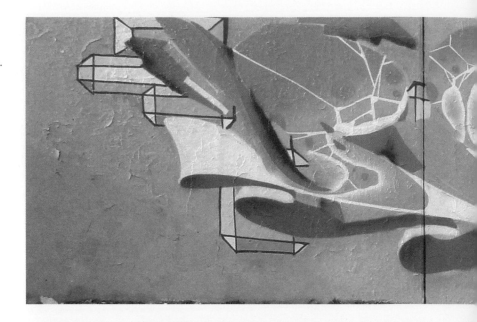

[5] **Outlines** Outlining letters and 3D blocks brings out the shape of the piece and makes the characters more legible.

Tip Use a skinny cap to get thin, clean lines. The overall outline around the piece should be thicker than the one used on the inside letters.

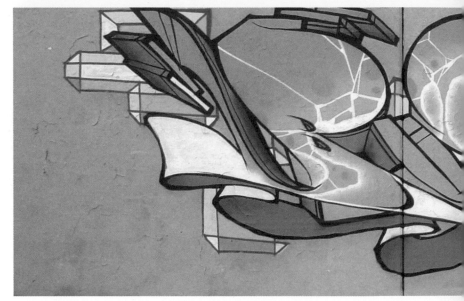

[6] **Effects** Designs like highlights, ligatures, lines that suggest movement, script and extra background patterns are added.

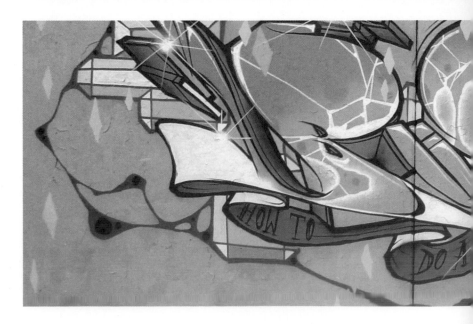

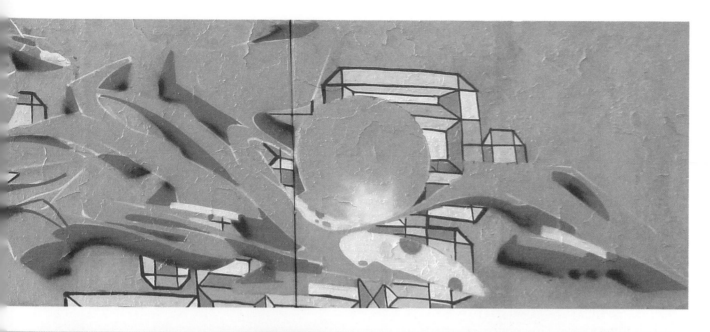

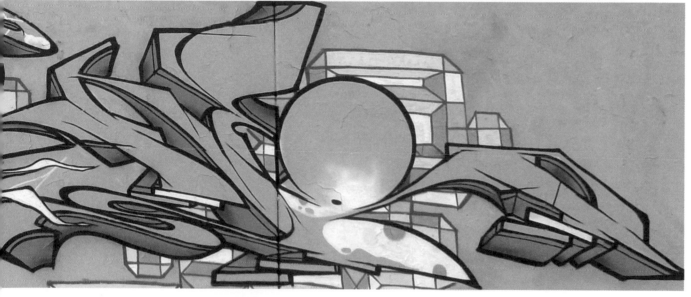

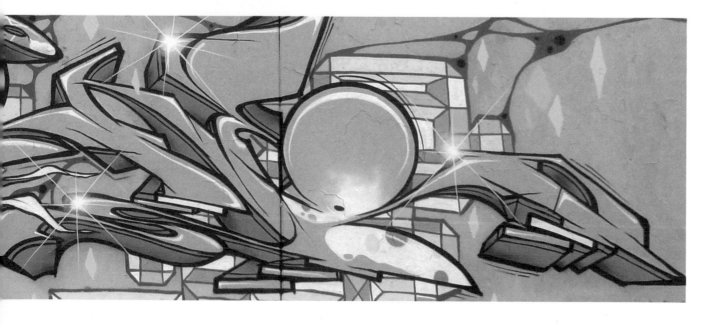

Design samples

When filling large areas of graffiti designs with several colours, it's important that they are arranged neatly. Every boundary between colours has to be considered and designed, and even colours in the border must have a form.

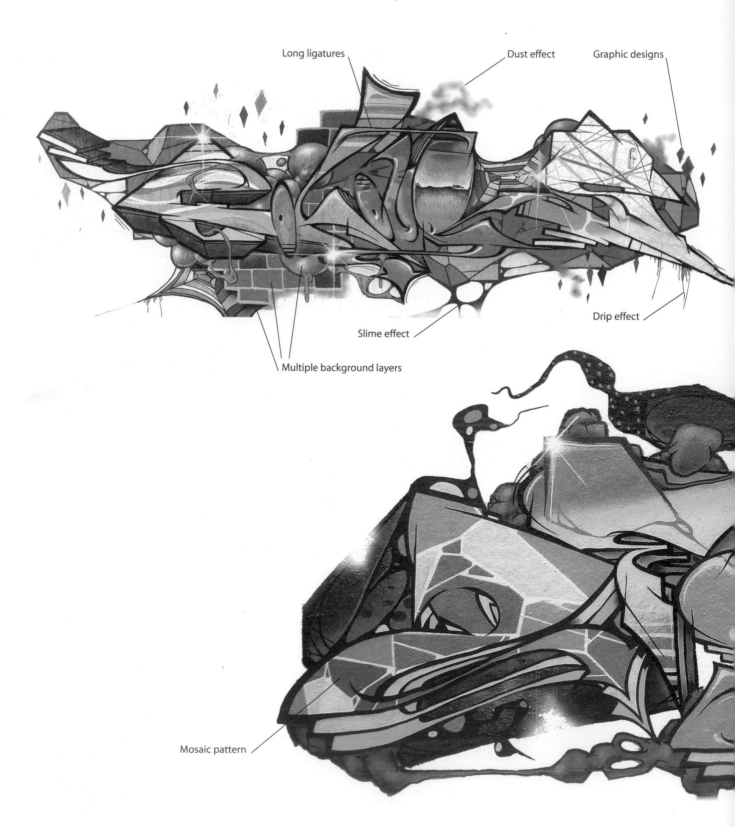

Long ligatures

Dust effect

Graphic designs

Slime effect

Drip effect

Multiple background layers

Mosaic pattern

You can also use divisions, ornaments or additional design elements to give structure to the spaces around the words. The following design samples show the basic elements. These fundamentals can be combined, extended and elaborated to fit the patterns and structures used in your work.

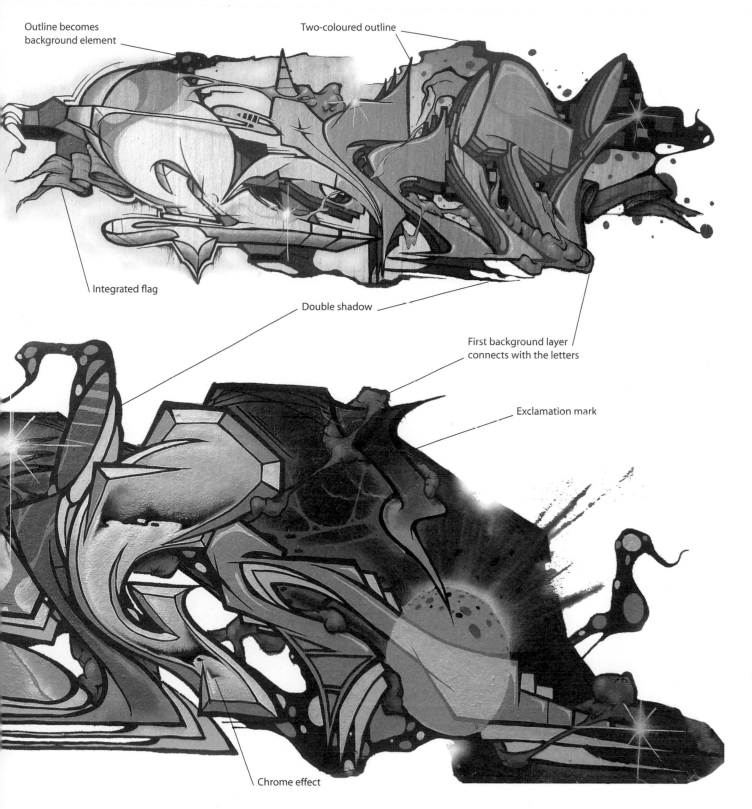

Outline becomes background element

Two-coloured outline

Integrated flag

Double shadow

First background layer connects with the letters

Exclamation mark

Chrome effect

Fill-ins

Letters can be filled in with a single colour, but fill-ins consist mostly of several colours, divided or arranged into patterns. Most writers consider their fill-ins and the associated techniques to be part of their style and so are continually refining them. Here are some ideas to start with:

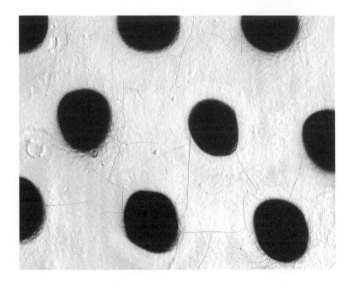

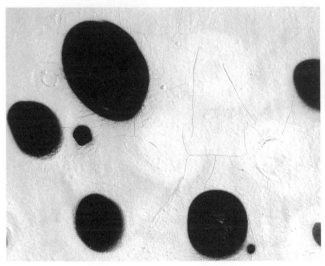

Circles and dots
[1] Regular

Circles and dots
[2] Irregular

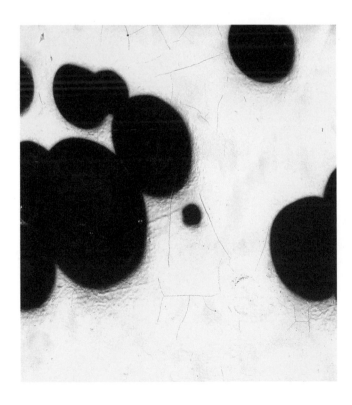

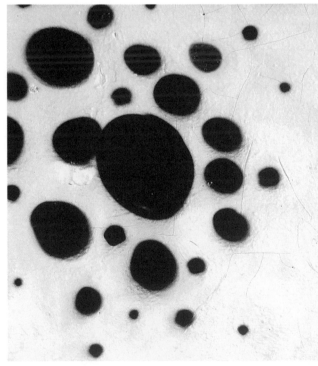

Circles and dots
[3] Overlapping

Circles and dots
[4] Clustered

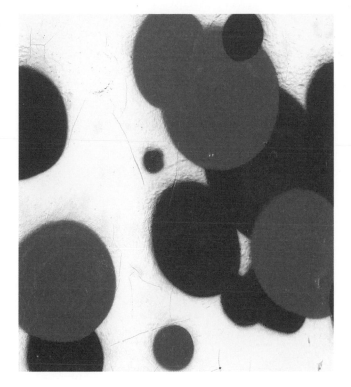

Circles and dots
[**5**] Overlapping another colour

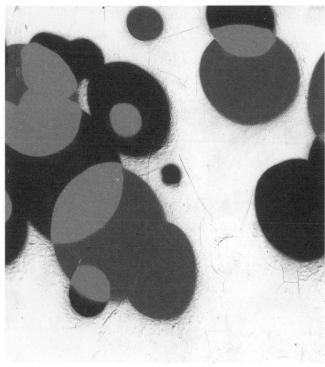

Circles and dots
[**6**] Intersecting

Circles and dots
[**7**] Multicoloured

Circles and dots
[**8**] Intersecting

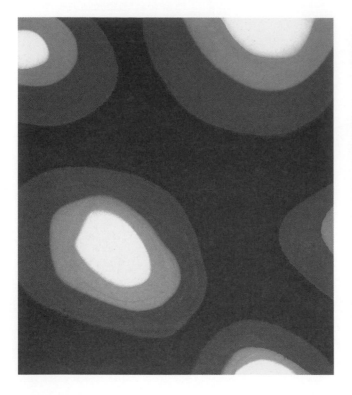

Circles and dots
[9] Targets

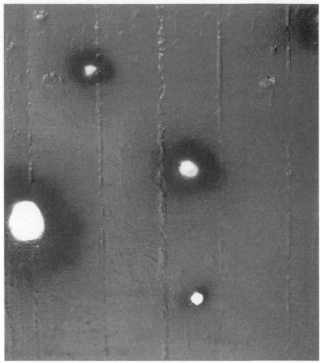

Circles and dots
[10] Sharp dots and fades

Circles and dots
[11] Hard lines over fades

Circles and dots
[12] Nebulous glowing dots

Fades
[1] Two-colour

Fades
[2] Multiple colour

Fades
[3] With overlapping lines

Fades
[4] With dots

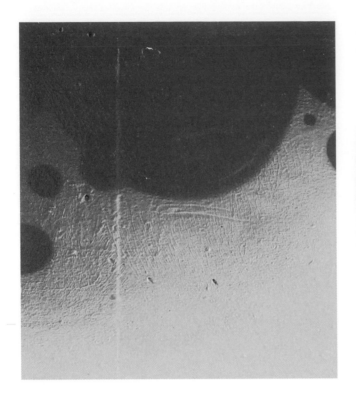

Fades
[5] With bubbles

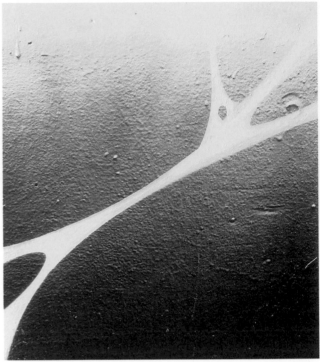

Fades
[6] With slime

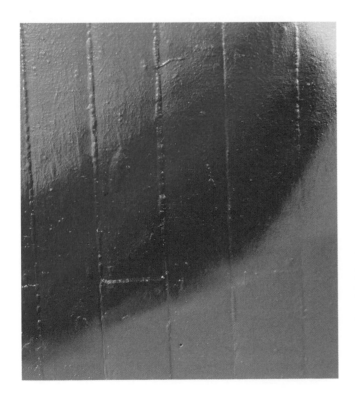

Fades
[7] Misty effect

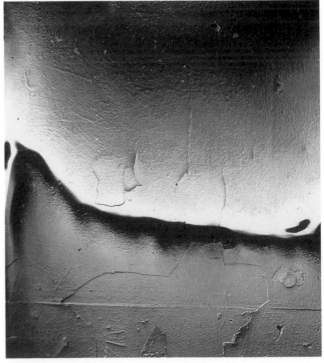

Fades
[8] Chrome effect

Fades
[**9**] Frozen effect

Fades
[**10**] Wild fadings with dust effect

Fades
[**11**] Wild fadings with sharp lines

Fades
[**12**] Faded edge

[4] Spraying graffiti

Fades
[**13**] Faded edge with dots

Lines
[**1**] Hard

Lines
[**2**] Hard with drips

Lines
[**3**] Hard with varying thickness

Lines
[4] Crossing

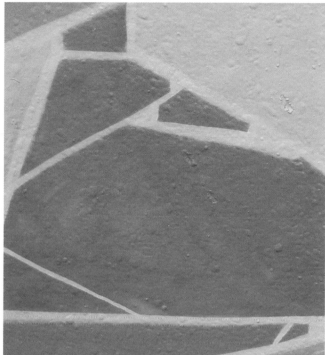

Lines
[5] Mosaic

Lines
[6] Plaid

Lines
[7] Mixed

Curves
[1] Lateral

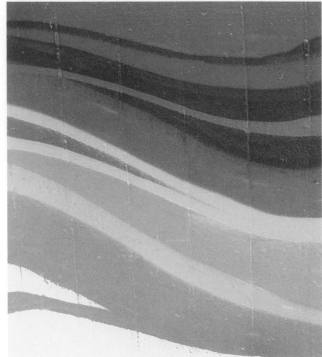

Curves
[2] Mingled

Geometric fill
[1] Mosaic pattern

Geometric fill
[2] Mosaic pattern with brighter sections

Geometric fill
[3] Triangle pattern with brighter sections

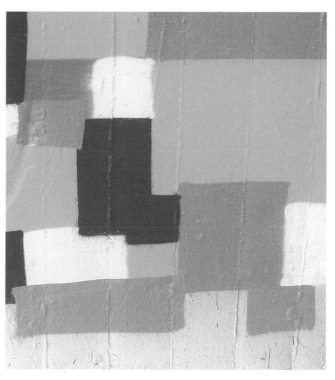

Geometric fill
[4] Small overlapping planes

Geometric fill
[5] Large overlapping planes

Geometric fill
[6] Combinations

Curved fill
[1] Circles and curves

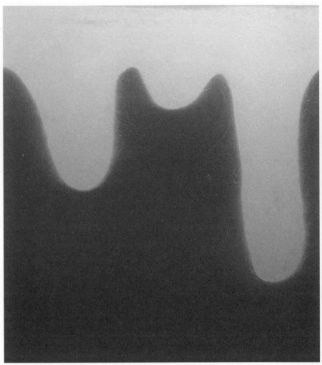

Curved fill
[2] Drips

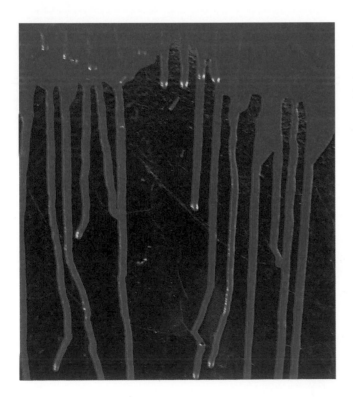

Style effect
[1] Drips

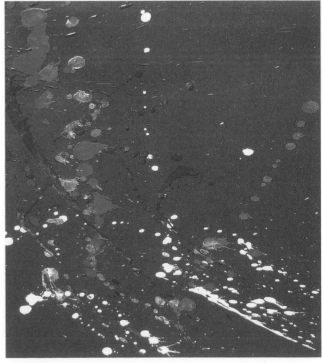

Style effect
[2] Splashes

3D blocks

3D blocks are used to give a piece profile or depth – another dimension.

The use of colour can make the 3D effect more convincing by imitating the shadowy or lit areas on the block. Blocks are usually painted in a darker colour when they face the bottom, and illuminated when they face upwards.

[1] Shaded to look 3D.

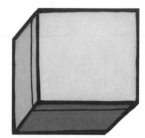

[2] With a thin line parallel to the outline of the face.

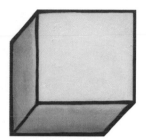

[3] Fading parallel to the outline of the face.

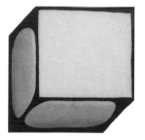

[4] Block areas with rounded shading.

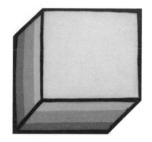

[5] Bars of colour parallel to the outline of the face.

[6] Outlined bars of colour parallel to the face's outline.

Transitions of light and shadow can be achieved in two ways:

[1] With fading

[2] With hard edges

Additional lines are often added to make this transition more elaborate. The outline colour can be used to create a clear contrast.

[1] With hard lines

[2] With shadow

Backgrounds

Background designs can interact with the letters in almost any manner imaginable. Since much of the overall space can be covered with background, elaborate pieces often combine many different layers. Here are some of the most typical background designs.

Bubbles [1] Flat
The most popular background elements are bubble structures – they are easy to do and are highly flexible designs. By laying circles of different sizes one over another an overall outline is formed, which can then be filled.

Bubbles [2] Outlined
Once a hard outline is added, more lines suggesting bubble structures can be added to the interior of the design. For the best results, the lines should narrow quickly and end in points.

Bubbles [3] Shaded
If a realistic effect is intended, fades suggesting light and shadow can be added to the bubbles.

Bubbles [4] Highlighted

Bubbles [5] With black and white

Other popular backgrounds are:
[1] Slime

[2] Bricks

[3] Cartoon explosion

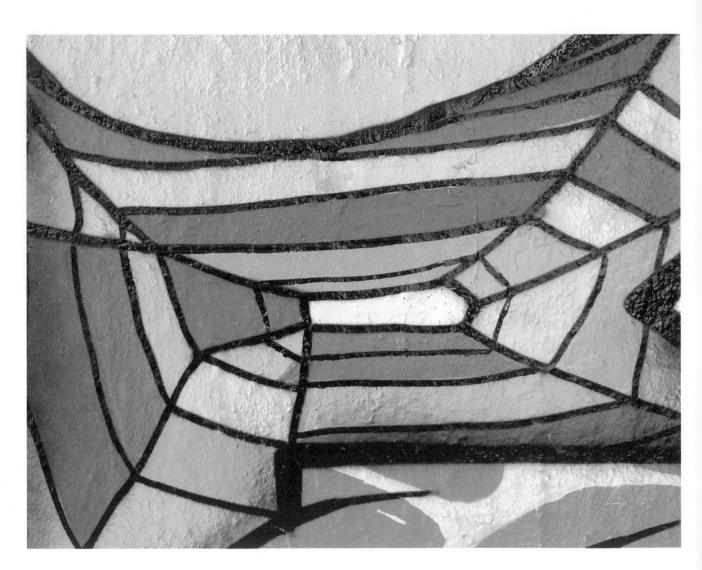

[4] Cobweb

[**5**] Warped chessboard

[**6**] Space
The space effect is a black background dusted in blue or violet using a fatcap from distance.

[**7**] Space with stars
White dots of various sizes are added to resemble stars.

[**8**] Lightning bolt
This spectacular effect, made using lines and dusting, works best on a dark background.

[**9**] Explosion

Effects

You can make your writing look more exciting by adding a number of effects. They help the piece to seem more clear by creating contrasts and imitating light and shadow.

For most effects, a dark background is preferable because colours appear brighter when surrounded by darkness. Faded and dusted colours look especially good on dark backgrounds.

From the starting point of outlined letters, individual effects are applied one by one.

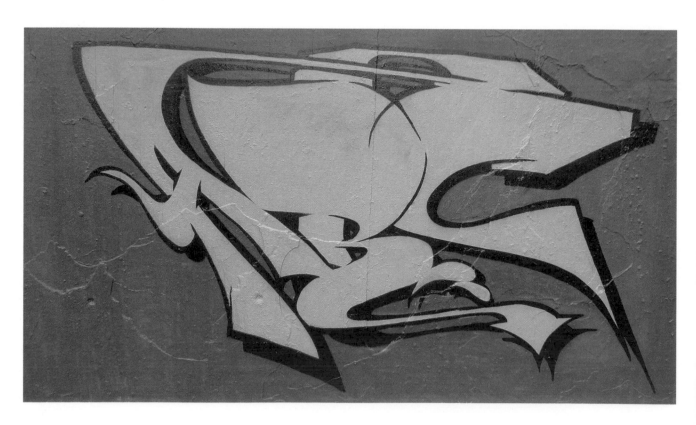

[1] **Shadow**. (See page 76 for instructions on how to add a shadow effect.)

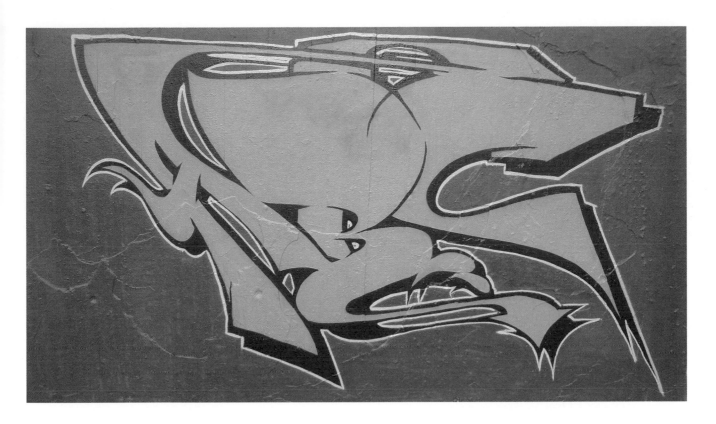

[**2**] A bright **outline** (also called a keyline) runs around the piece, increasing the contrast between the background and the fill colour.

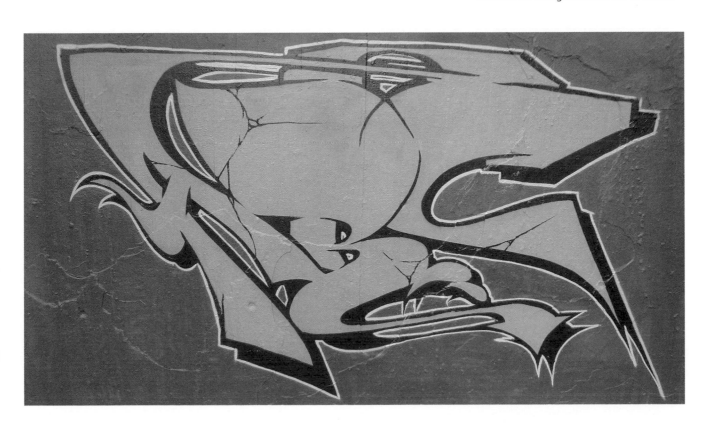

[**3**] Thin **cracks** of varying thickness make the letters look tactile and textured. For this effect use cans that are almost empty, low on pressure or have caps that are nearly blocked.

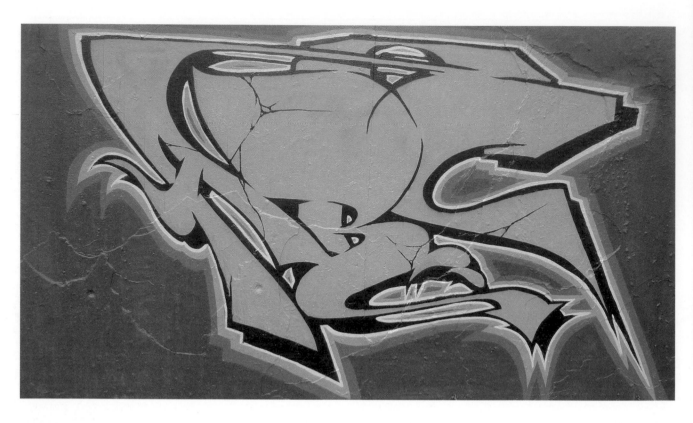

[4] Aura (hard version)

An 'aura' is an enhanced kind of keyline; it adds a glowing halo around the piece.

A strong-looking aura can be made with hard lines and areas of a single, unblended colours.

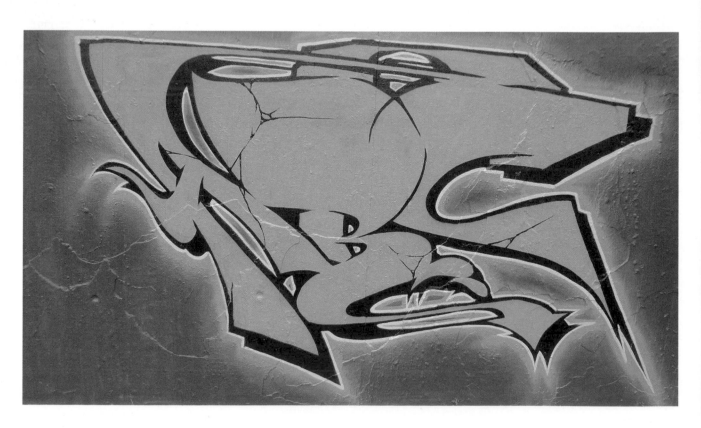

[5] Aura (soft version)

In a soft aura a number of colours or shades fade into one another.

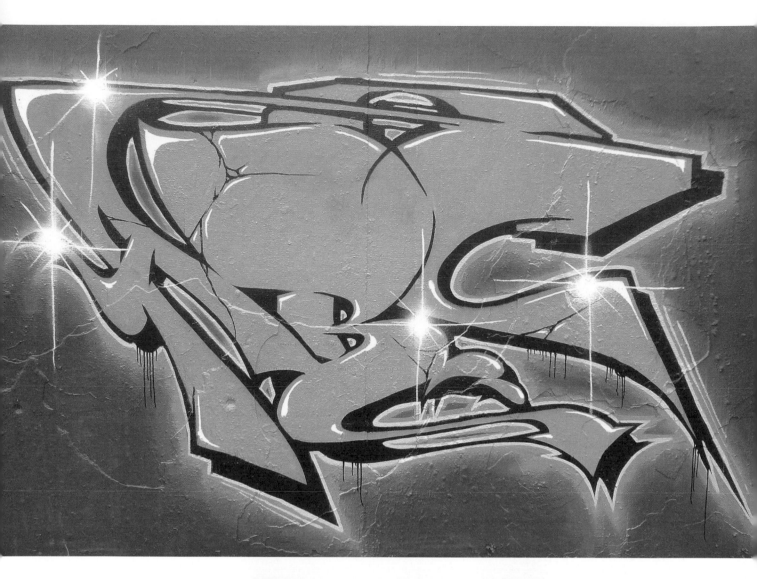

[6] **Shines** and **drips**

Where a space is left between a letter's highlight and outline, the letter's surface appears to have a 3D 'dome' effect. Also, highlights that are set apart from a letter's edge (i.e. highlights that don't run exactly parallel with the letter's outline) leave space that suggests a deviation from a perfectly even form. For example, making the highlights thickest in the corners gives the impression that the corners are realistically rounded like the curved bodywork of a car. Darker fill-ins and lighter highlights give the most contrast. You can make it seem as if your letters are catching the sun by adding a sparkle effect. Put bright stars on the corners of highlight lines so your letters shine.

Tip Do not overuse sparkle effects – too many and the effect loses its strength. Highlighting the prominent and interesting parts of a few letters is enough.

[7] **Dewdrops**

Dewdrops are done with 'transparent' paint (paint with a low pigment volume) or white paint used thinly. The white is faded on the inside, while given a hard edge on the outside. To imitate the round surface of a dewdrop, a reflection highlight is added on one side and a darker colour to the other to represent the shadow underneath the water droplet.

125

Background layers

Complex backgrounds can join letters together, giving a sense of structure and a balanced overall shape. Or, instead of using 3D blocks or shadows to create the impression of depth, why not try overlapping the background layers?

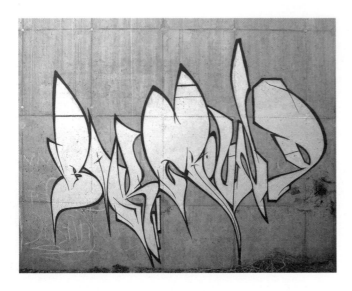

[1] The first layer is an outline for the letters, here done in black and a white fill-in. (Note that normally, the background is filled in before the outline – this avoids unnecessary touch-ups.)

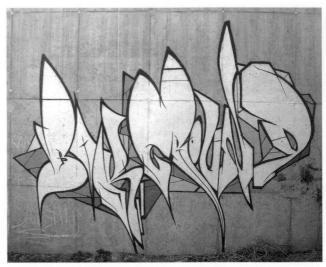

[2] A second (and sometimes even a third) layer can then be added. Overlapping sections of the background ensures that this seems a single, unified element.

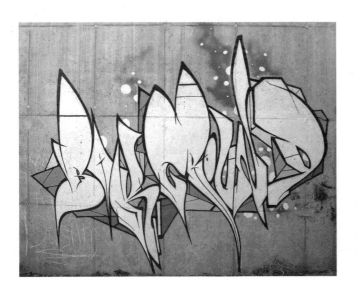

[3] Adding dust effects and other details makes it eye-catching.

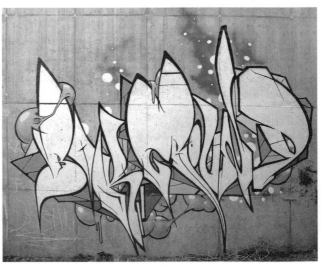

[4] Trails of slime creeping over the letters create more layers, increasing the apparent depth of the piece.

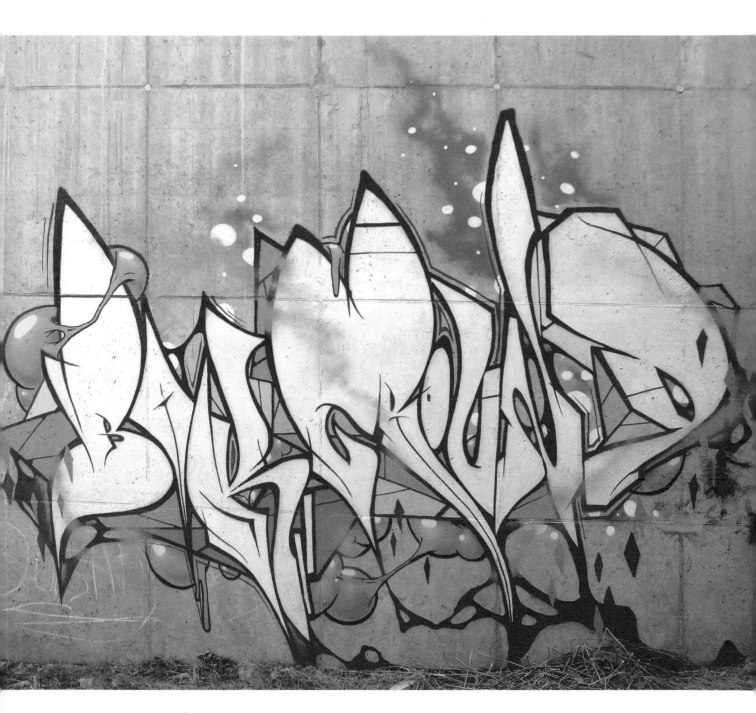

[**5**] Fragments of an offset red keyline
are added and the piece is finished.

Dos and don'ts

Useful tips …

… for saving money:
- Use wall paint from DIY shops to fill in your backgrounds and letters. This is especially good value if you buy a big tin, and more than one person wants to use the colour. Remember, wall paint takes longer to dry, so it's best to use it on warm days.
- Ask professional painters and decorators for left-overs or incorrectly mixed tints – you might get some paint cheap or even for free.
- Always read the storage tips on spray cans and paint tins.
- If you put trays of unused paint and used paint rollers in an airtight plastic bag they will stay fresh for days and you won't need to throw paint away.
- If a cap blocks, try to unclog it by shaking the can to build pressure and turning the cap before spraying. Or put the cap on a higher-pressure can.
- Take almost-empty cans out with you. The last drops of colour could be enough for a small detail.
- If you don't want to carry old clothes around with you to paint in, you can always turn your good clothes inside out. Stains on the inside aren't as bad as stains on the outside.
- If you do get stains on the outside try using a stain remover. Some are more effective than others and so you might need to try a few before you find the right product. Cleaners that remove nail polish or chewing gum usually show good results, but test them on a hidden area – just in case!

… for saving time:
- Arriving with a good plan helps you to sketch up fast and mark out which areas will be filled in at later stages.
- Work in layers – not one letter after another.
- Start on the outline only once the fill-in has been done.
- When you prime a wall in low temperatures, sketch the letters up first and then prime the background around. This way, the letter outlines are unpainted and dry, so you can start work on filling them in while the background is still drying.
- Tinting dark wall paint with some black acrylic improves the coverage.
- Small mistakes or dirty spots on a wall can be concealed with shines.
- Silver chrome is the best-covering paint (but it also fades quickly when exposed to the sun or touched).
- Metallic colours have to be completely dry before you go over them. Even then they sometimes react with other colours, causing them to drip. It's best to check that your metallic paints don't react with your colour paints before you start on a piece.

Code of behaviour

Respect other writers and their work! Only go over pieces that are damaged or defaced, or ones you know you can improve on.

Recycle empty cans, don't leave them around. Not only is it littering but also the last few drops of paint might be used to ruin the piece you've just finished. It's important to take all your waste away with you: legal walls can be closed down if the place is filthy.

Spraying on canvas

Even though they're not designed for it, spray cans may also be used on canvas or artist's board. Since the spray can is a relatively rough and imprecise device, most artists use specialized tools and accessories to help them when painting. They employ stencils, masking tape or even gloved hands to cover areas of the canvas, preventing unwanted spray dust reaching the surface.

After using spray for the fill-in of a smaller-format graffiti artwork, acrylic markers are useful for drawing outlines and executing small details. Artists who have more experience develop their own techniques, which may include using brushes, solvents, plastics and foils to achieve specific effects.

The following pages show how these techniques and tools are used to complete a graffiti piece on a 100 x 50 cm (40 x 20 in.) canvas.

[1] Sketch the letters

First use a pencil to draw in the outlines. After that, draw over your lines using an alcohol-based marker. Spray paint does not cover alcohol-based inks well, so your outlines should still be visible even after the letters are filled in. Although this makes later corrections or touch-ups much more difficult, it is the only way to see important outlines after spraying the fill-in.

[2] **Filling in the letters**

Carefully apply the paint in thin layers; thick coats take a long time to dry and will slow you down. You can use masking tape or stencils cut from card to create detailed fill-ins.

[3] **Add a background**

Once the paint on the letters is dry, they can be masked with tape and paper. To avoid needless work, areas which will later be covered with 3D blocks or other background layers don't need to be masked.

Tip Pressing down on a thick coat of wet paint with plastic foil or paper can produce an interesting 'marbled' effect.

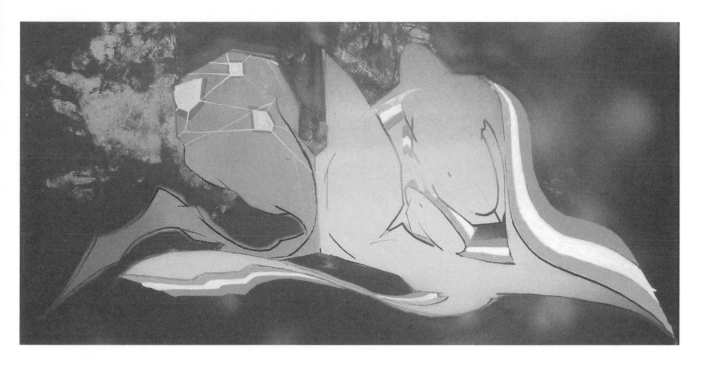

[4] Add 3D blocks and designs

To avoid all the tiresome taping, small details or areas can be drawn or filled in using acrylic markers. It's best to wait for the paint to dry before doing this – wet paint will scratch off the canvas and ruin the tip of the pen.

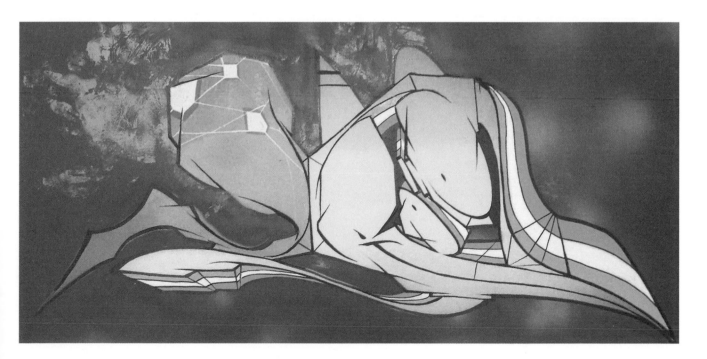

[5] Add an outline

Lastly, the outlines can be drawn using a marker pen.

[4] **Spraying graffiti**

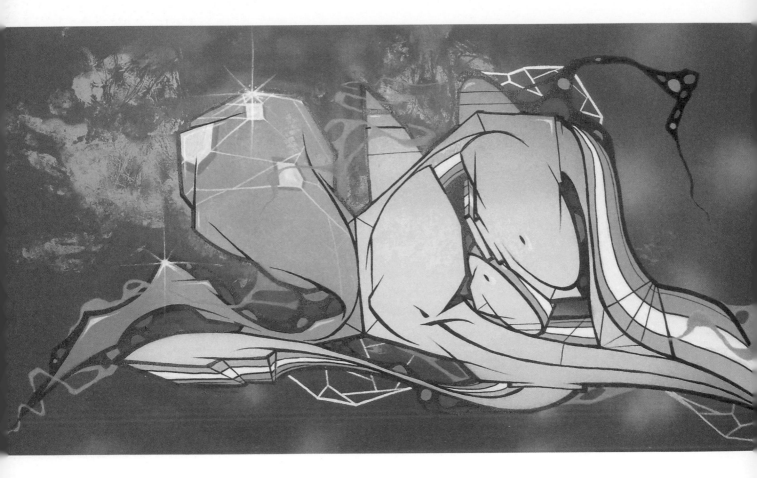

[6] **Final effects**

Final effects (such as highlights or background designs) are added and the piece is complete.

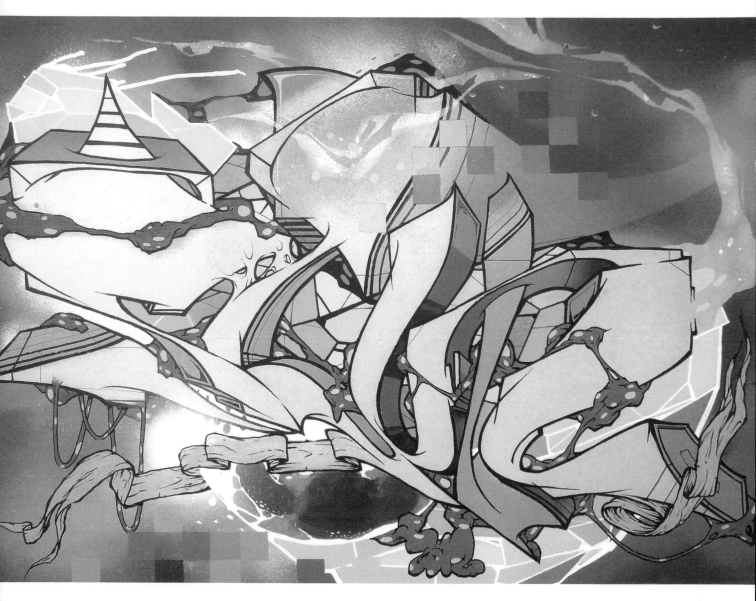

With practice and technical know-how, you
will be able to realize more detailed pieces.

[5] Teacher's manual

Graffiti at school

The question of whether graffiti is a suitable topic to be taught in schools or youth centres is a controversial one, and this alone may well put teachers off including it in their curriculum. However, the discipline's disputed position – sitting awkwardly between art and vandalism – is not in fact an obstacle but should be seen as the central theme. This creative, expressive form should neither be unconditionally approved, nor irrationally dismissed as non-art; rather it should be discussed and analysed on an impartial basis. It's important to remain objective when teaching lessons about the graffiti movement. Inviting students to think critically about the phenomenon is more likely to stop them defacing other people's property than ignoring the topic entirely.

Ignoring a form of art that appeals so strongly to young students would almost certainly mean missing an opportunity to capture the interest of so-called 'difficult' teenagers. Graffiti's connections with such popular and pervasive youth cultures as Hip Hop guarantee that teenagers at all kinds of schools and from all social backgrounds will pay it attention in the classroom.

If the overall aim of the subject at school is to encourage pupils to get involved with art on both a practical and a theoretical level, then graffiti style writing can help: either as a way of encouraging classes to think about practical art themes such as complementary and contrasting colours, negative space and creating 3D effects, or as a way of introducing the more rebellious and recent aspects of contemporary art scene through the works of artists such as Jean-Michel Basquiat and Banksy.

Other components of the Hip Hop movement are also modes of creative expression that might be examined simultaneously in other lessons, creating a larger cross-subject theme. Rap, for instance, has been successfully used in English lessons examining poetry, DJing can help with introducing and analysing popular music and breakdancing would fit in with lessons on modern dance. The added benefit in all these pairings is that as Hip Hop culture is already considered cool, a wider and more committed level of participation can be expected.

Although introducing graffiti into lessons has the potential to produce very positive outcomes, it should not be done without thoroughly thinking through the various consequences that are likely to arise. For example, pupils will want to test their skills in a hands-on manner, and this means that there must either be a safe, legal wall near by, or a school-owned training area (a wall or wooden boards of a decent size). Teaching students the theory without giving them the scope to test it out would not only cause problems but would also be unfair!

There is always a chance that students will use graffiti in an unsuitable manner; however, unauthorized graffiti occurs in every school regardless of whether it is a subject or not. A taught lesson, putting emphasis on the aesthetic–artistic dimension of graffiti and the opportunity for individual expression (in the right environment), can guard against unwanted graffiti.

The power of graffiti

Another reason for bringing graffiti into the classroom is its social inclusivity. During formative years, when teenagers are trying to relate better to others while discovering their own identity, graffiti can be both a confidence-boosting hobby as well as an excellent means of social networking.

All teenagers – no matter what nationality, mother tongue or academic level – can communicate using a non-verbal form of expression such as graffiti; it's an entirely level playing field where the results on the wall count. Even teenagers who have been ostracized can experience acceptance and success within the graffiti scene. Replacing your name with an alias affords the opportunity to build a new identity.

This opportunity is also partly due to the scene's code of behaviour. Graffiti ethics are based on values such as mutual respect and tolerance, giving all participants a fair chance. It also means that graffiti teaches social skills, as well as artistic ones. But this tolerance doesn't mean graffiti is easy, or taking part a guarantee of success and talent. Anyone who wishes to become a respected graffiti writer must invest a lot of time and energy in order to improve his or her skills. The discipline and practice associated with the hobby combine to create character and boost self-confidence and self-esteem.

A mutual interest in graffiti can help form friendships, which can widen to produce crews of writers who go painting together and help each other when needed. Some crews even go so far as to stop writing their individual names and instead write only the crew name, which creates an even stronger sense of community. A crew's differences in age, skin colour and social background have no effect on their common interest in graffiti.

As with any subject, a workshop or lessons at school can serve only as an introduction. Yet graffiti's social benefits and reputation for being 'cool' are not only initially attractive to young students, but also factors that can increase the chances that interest will continue once lessons have stopped.

These are just some of the advantages that can be enjoyed if graffiti is chosen as a hobby. At the same time – no matter how excited young students are by the power of graffiti – they must be reminded that spraying graffiti on walls without permission is illegal and an offence that may lead to prosecution.

To help stop teenagers getting into trouble, city councils should offer a reasonable number of legal walls. If young graffiti artists are given a choice between executing their art legally and committing a criminal offence then it's likely they will prefer the former. And if there isn't a legal wall in your town? Why not suggest to your class that they write a letter and sign a petition, and send these on to the local authority.

Teaching graffiti

Up until now, practical graffiti units in art curriculums have been rather rare, perhaps because many teachers lack experience, know-how and confidence in this particular field. Also, teaching groups of 20–30 students how to spray graffiti requires a lot of organization – and space!

How a workshop is conducted, what its aims are and the activities that can be offered all depend greatly on the size of the group, the space available and the budget – though even with a large group, a small space and a

minimal budget it is possible to teach aspects of graffiti. What follows here are a series of ideas. You will have to tailor and mix the suggestions to create a plan to match your needs and resources.

A large group or small classroom means that simultaneous spraying probably isn't sensible. The solution is to get the group working on paper; this allows them to practise designing beautifully shaped letters independent of walls or spray cans. While the majority of pupils are working at desks, one or two pupils at a time might be allowed out of the lesson to work with a teaching assistant or formally authorized local graffiti tutor/artist. This way all students would get to handle a spray can over the course of a project.

The likelihood is that you will have to divide your class up into groups, with each group aiming to work together to produce a piece of graffiti.

Working simultaneously on the same piece in large groups requires a lot of planning. Different tasks (such as fill-in or background) can be assigned to small groups.

Together, using the images and effects shown earlier in this book, the group will begin to draw and develop a sketch. The group will then divide up the various stages of producing the final piece (from transferring the sketch to the wall and outlining the letters, to adding the background, the fill-in and 3D blocks) among themselves.

Although spraying on canvases or wooden boards (see pages 129–33) is not the most authentic option, it's a good alternative if there are no suitable walls at the school. Between lessons the boards can be stored easily, and after they're finished you could repaint them or let the students take their artwork home.

In order to ensure that students are gaining both theoretical and practical insights into the art and culture of graffiti it's important to precede any practical exercises with a short theory course, unit, presentation or conversation. The basic elements that should be covered are: firstly,

the origins of graffiti (understanding the historical background and social context helps understand the motivation of those who write); secondly, agreeing on a definition; thirdly, communicating the consequences of illegal graffiti; and fourthly, a brief lesson outlining the health and safety issues of working with spray cans.

Planning a graffiti unit

Graffiti as a classroom subject can be divided into a series of logical steps. The skills gained at each stage build on one another, which means that completing them in the following order is the most effective way of learning.

The complexity of different graffiti styles varies considerably. While tags are comparatively uncomplicated in structure, designing a decent wildstyle clearly takes a greater ability to visualize the finished graffiti as well as more style expertise.

This difference in complexity between tag and full-colour piece allows you to match a graffiti style to a group's ability. The three factors that can turn simple graffiti letters into an elaborate ones are:

[1] Changing from a single line to outlines.
[2] Changing from flat to 3D form.
[3] Changing from black-and-white to colour.

The most useful way of learning the practical skills of graffiti is to begin with practising tags on paper and end with perfecting colourful style pieces on walls. What follows is the structure observed by most graffiti units, and it is also the structure of this book:

[1] Find a definition and explore graffiti's historical background.
[2] Learn tags.
[3] Introduce the outline.
[4] Learn throw-ups with shadow and 3D blocks.
[5] More complex graffiti styles and style elements.
[6] Realizing a sketch using a spray can.

It's important to supplement the learning process with suitable visual aids (such as magazines and books); these can give inspiration and help inexperienced writers develop ideas for their work. Trips to see local graffiti walls are another great way of finding out what writers are doing.

Incorporating media

A teacher with little or no experience of the subject might feel less-than-confident delivering a session on graffiti. An alternative is to invite a specialist to deliver a talk on their work, methods and the scene in general. No number of magazines, books or DVDs can make up for a expert who's willing to talk and take questions – even better if they can demonstrate a few aspects of graffiti.

At the start of the unit, one way to get students interested in the topic is to screen a movie such as *Beat Street* or *Wild Style* (the latter usually receives a higher certification). Both titles convey an authentic picture of the early days of graffiti as it emerged from Hip Hop culture. Beforehand you should remind

the class that the plots are not the focus – the most interesting aspects of these productions are their scenes and settings, from which we can gain impressions about the background and motivation of the graffiti writers.

Sample lesson plan

The best way to open the topic is by picking out examples of writing from history that are similar. A number are mentioned on pages 10–13 of this book (and you could widen the topic to examine analogous 'drawn' examples, such as ancient cave paintings). Discussing what these examples have in common and how they are different is the best way of arriving at a definition of graffiti.

Topic
Finding a definition and setting graffiti in its historical context.

Materials
Photos are shown on an interactive projector or whiteboard.

Learning objectives
Over the course of the lesson students are presented with a variety of images showing historical precedents for modern graffiti. Together the class discusses their similarities and differences. (The chart on page 14 provides some useful terminology and categories that may direct this discussion.) Students should agree on a definition of graffiti that explains both *what* graffiti is and *where* its origins lie.

The lesson
Introduction The lesson begins by assimilating pre-existing knowledge about modern graffiti. What have students deduced from the walls around their neighbourhood, or from TV and film media? Direct the discussion towards the question of how old the concept of graffiti might be.

Main section To help answer this question, pictures of the following are projected (in chronological order). If possible, to make the exercise easier, additional information should be given alongside the picture. The most important things to mention are: firstly, where the drawing or writing was carried out (graffiti must be in a public space); secondly, what the writing says (graffiti must be individual self-expression). The following two questions are then asked of each image:

[✔] What similarities to modern graffiti do you see?
[✘] In what ways does the subject differ from modern graffiti?

[**Picture 1**] **Prehistoric cave painting** *c.* 35,000 BC
[✔] Painted as a means of visualizing and communicating ideas.
[✘] Anonymous; not painted with a spray can; painted in caves (not a 'public place' as we understand it).

[**Picture 2**] **Ancient Egyptian hieroglyphs** *c.* 3,500 BC
[✔] Displayed in public spaces like graffiti.
[✘] Carved, not sprayed; mostly communication by an authority rather than individual self-expression.

[**Picture 3**] **Graffiti from Pompeii** before AD 79
[✔] Done without permission in public spaces; desire for self-expression.
[✘] Mostly scratched onto walls, not sprayed.

Additional exercise A huge range of Roman graffiti remains on the well-preserved walls of Pompeii (see pages 10–11). From it we learn that the Pompeians marked the stones for many different reasons. Here are translations of three inscriptions. What different kinds of messages are being expressed? What was the writer's motivation?

'Celadus the Thracian gladiator is the delight of all the girls.' [Self-promotion]
'Perarius, you are a thief.' [Communication of opinion]
'Vote for Lucius Popidius Sabinus; his grandmother worked hard for his last election and is pleased with the results.' [Advertising]

[**Picture 4**] **Illuminated capitals in Bibles** from *c.* AD 500 onwards
[✔] Decorative letter designs in colour (often with 'cartoon' characters).
[✘] Religious texts on paper; mostly not intended to be linked to the artist.

[**Picture 5**] **Josef Kyselak** *c.* 1820s
[✔] Written in a public space; attracting attention to the writer's name.
[✘] Almost identical to modern graffiti (but predates the spray can).

[**Picture 6**] **Taki 187** 1960s–1970s
[✔] Writing a pseudonym on a wall in public space using a spray can; the definition of modern graffiti writing.

Alternatively, students can form groups of 3 or 4 and attempt to order the pictures chronologically and answer the questions regarding similarities and difference. The whole class can then discuss a definition.

Conclusion Graffiti is not an entirely recent phenomenon; the most important features are the location of the text and the presence of a name (or pseudonym).

Sample exercises: graffiti theory

This exercise is designed to compare public advertising with graffiti. The key aspects that will be examined are the purposes, the visual consequences and the justifications of each. The discussion should consider the practical and ethical questions posed by both forms. The comparison with advertising and ensuing discussion will be far more fruitful if those involved have already agreed on a definition of graffiti and a sprayer's possible motivations.

Course of action

Contrasting photos of graffiti and advertising (such as those shown opposite) are presented to the class. After a brief conversation concerning what can be seen in the images, the central questions of the exercise are raised:

What characteristics make graffiti and advertising different?
What characteristics do graffiti and advertising share?

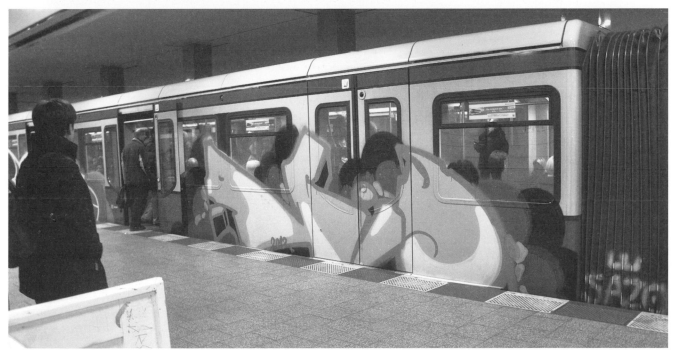

Differences between advertising and graffiti:

– Most advertising is legal, most graffiti is illegal.
– Advertising is usually publicly accepted, graffiti is usually not.
– Advertising companies pay to use allotted space; sprayers work anywhere they can reach, risking fines and imprisonment if caught.
– Train companies are paid to feature ads but have to pay for graffiti removal.
– Advertising is used to promote a company or product; writers want to promote their name in the scene.

[**Top**] An 'end2end' Coca-Cola advert on a tram in Portugal. Similar adverts have appeared on trams all over the world, from Tallinn, Estonia to Hokkaido, Japan.

[**Above**] A panel on a German commuter train by Acid.

Similarities between advertising and graffiti:

– Both use public space.
– Both are created without the explicit permission of the people using that space.
– Both rely on largely visual means to attract attention and improve reputations.

The following questions can be used to continue the discussion:

Which one do you like more? Why?
Why is advertising legal but graffiti illegal?
Who has made each image and what did they want to achieve?

Alternatively, these questions can be considered (in pairs or larger groups), presented to the class, and followed by a full-class discussion. It's a good idea to see that these general points are covered:

Pro-Advertising

– Adverts consist of clear messages, intelligible to most of society; graffiti is usually undecipherable to the majority.
– Companies that host adverts can (or at least should) use the revenue generated to cover some of their costs, and so indirectly save the customer money.
– Graffiti can cost the public money; for example, ticket prices are likely to rise if a train operator experiences increased cleaning expenses.

Pro-Graffiti

– Graffiti are mostly individual artistic expression; ads are generic forms often used to promote mass-market goods and facilitate consumerism.
– Graffiti is a creative force within youth culture.
– Even illegal graffiti is a mark of determination, bravery and individuality.
– Consumers indirectly pay for ads through higher product prices.

Conclusion of the comparison

Graffiti and advertising share many characteristics. In a way, graffiti can be considered as personal advertising, not for a product but for an artist's identity. Both can be perceived either as creative/artistic or as visual pollution. The cost of cleaning illegal graffiti – paid by the public or building owners – gives graffiti anarchistic and potentially anti-social connotations.

Sample exercises: practical graffiti

In order to teach the students the basics of letter structure and design, a blockbuster exercise (similar to that on page 44) can be given out, and students challenged to then invent their own alphabet. In creative lessons it can be helpful to provide examples that show the possibilities that exist when designing letters or to help students who are stuck. Completed alphabets such as Tag, Throw-up and Style (pages 154, 155 and 161–62) are good visual references and copying from complete alphabets helps students learn and transfer letter shapes.

The next step is to ask students to arrange and connect letters in a new order. Graffiti magazines are a good primary resource for letters – though

the difficulty level is much higher since the examples rarely contain all the letters needed to write a full name. Missing letters will need to be designed individually, which is quite challenging, even though elements of the original style can be used to build the required letters. (Remind them that it's difficult to combine letters from two or more examples since the different styles often clash.)

The next stage is to add new elements – such as shadows, fills and cartoons. Integrating these successfully is a big step towards achieving an individual style.

Remind the class to work initially in pencil before tracing definite outlines in ink. Also, watch out for students tracing graffiti magazines! Examples should be a source of inspiration, and not a master copy.

Marking work

Although subjectivity and personal taste will define a critical opinion of graffiti to a certain extent (as it will when marking work done in any creative subject) some letters unquestionably look *better* than others: they are proportioned, balanced and harmonious; fit well together; and the artist's creativity is discernible. A list of specific individual criteria might be:

[1] Are the letters designed by the student? (I.e. not copied!)
[2] Is a consistent style maintained throughout the piece?
[3] Do the letters sit well together to create a pleasing shape?
[4] Are effects such as 3D blocks, shadows and highlights used correctly?
[5] (If relevant.) Do the colour selections work well with the letters?

You could also include the class in the process of grading. If five images of graffiti are shown, discussed and ranked according to an agreed set of criteria, these criteria can then be developed into a marking system. It is best to use pieces selected from writers outside the class, so no student feels their work has been singled out for criticism or low grading.

Alternative graffiti-based activities

Here are some other activities, besides theoretical and practical exercises, that could be considered when teaching graffiti:

[1] A graffiti safari through the city. This can both serve as an introduction to the different disciplines of graffiti, and show how specific examples can link with their local environment. If there are enough examples in your city or town, then students can take photos in small groups. Later these may be presented, compared and classified. Many of the examples you will see will be illegal graffiti, and so it's good to balance a safari with suggestion number 2.
[2] A visit to the local hall of fame. The importance of showing students that there is a talented and burgeoning legal graffiti movement in their home city cannot be over-emphasized.
[3] A gallery trip. Keep an eye on the programmes of local art spaces – there may well be an urban art exhibition. Artists often give talks or Q&A sessions, and such discussions help students get to grips with the fact and fiction of graffiti.

[Exercise] Style 1

Complete the alphabet.

A	B	C	D	
F		H		J
K		M		O
P				
U			X	
Z				

Solutions are shown on page 161.

[Exercise] Style 2

Complete the alphabet.

Solutions are shown on page 162.

[Exercise] Styles for outer shapes 1

Complete the letters using the given keys areas.

[Exercise] Styles for outer shapes 2

Complete the letters using the given keys areas.

Below are some possible solutions to the style exercises on page 146 and 147, as well as some other styles.

classic swing

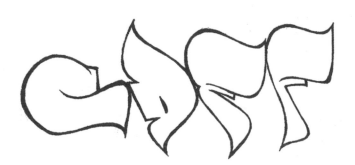

round shapes with pointed endings

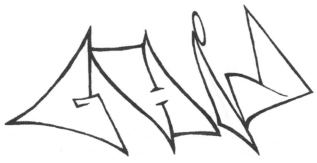

curved triangles

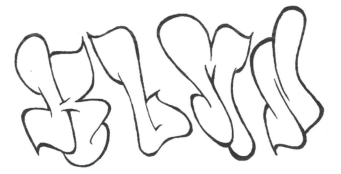

bubblestyle letters

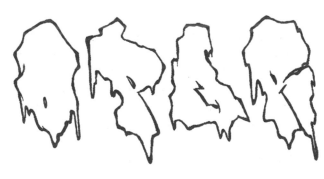

organic shapes

geometric shapes

style letters

Practical exercises for teaching basic techniques

These activities are suitable for small- and medium-sized groups; some will even work with greater numbers. They're designed to give students a first taste of making marks using a spray can. As with all the exercises in this book, it's worth delivering instructions before handing out paints, and you should ensure the workspace complies with the recommendations on the backs of spray cans.

Learning basic techniques

[Exercise 1] Drawing clean lines

Drawing clean lines requires the writer to move the can swiftly, at an even pace and at an even distance from the wall. Remind students to bend their knees when spraying a line that curves down, and to shift their weight from one leg to the other when drawing longer horizontal lines. Remember that the smaller the distance between cap and wall, the sharper the line will be – but there is also a greater chance of the paint dripping if the can movement is too slow. First try a fat cap, and then use a skinny cap.

[Exercise 2] Spraying a clean square

To draw sharp angles you must stop spraying a line and then start again in a new direction. This means drawing the four sides of a square separately, and developing good timing (remind students to start moving the can before pressing the cap to prevent drips). Students should start with a 1 m [3 ft] (or bigger) square, and draw smaller concentric squares inside. They should use a skinny cap for this and try to achieve parallel lines.

[Exercise 3] Getting different thicknesses of line

To achieve thick lines keep the can further from the wall and move it slowly. When drawing thinner lines the can must be moved more quickly, and kept closer to the wall. When students have mastered lines and letters of different widths they can try changing the distance to the wall while spraying to achieve a line of varying thickness.

[Exercise 4] Creating a soft fade

To create fade effects, students must learn to hold the can at an angle to the wall. The thicker and more powerful the release of paint, the softer and longer the fade will be. Once the group has mastered fades using a skinny cap it's time to move on to a fat cap.

Tip Suggestions regarding safe use and storage of spray cans may be found on pages 91–99.

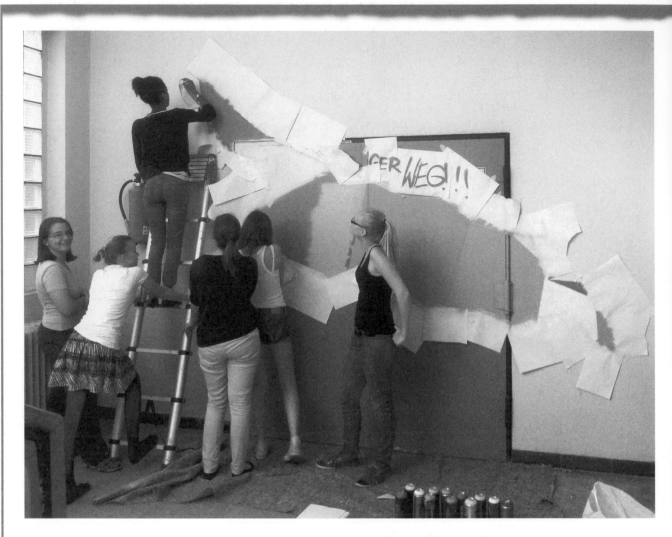

Before starting any large-scale group work it's important to agree a safety code with students. Ladders should be used correctly and spilled liquids should be dealt with immediately.

[Exercise] Connecting coloured areas

This exercise isn't – technically – graffiti, as it doesn't involve lettering; however, connecting areas of different colours in an interesting way remains a basic skill that all graffiti writers must master.

The focus of the lesson should be on creating an interesting variety of shapes and colours, but this exercise is also excellent practice for completing consistent fill-ins without drips. (To help less-experienced students achieve impressive results, hard edges can be created by using masking tape.)

First, students should use the tape to mark out the overall shape. Sharp angles, variations in proportions between individual areas, and the overall shape of the structure should combine to create an interesting design. Once the design is final, surrounding surfaces should be covered with paper or plastic to protect them from overspray. A colour scheme should be decided on.

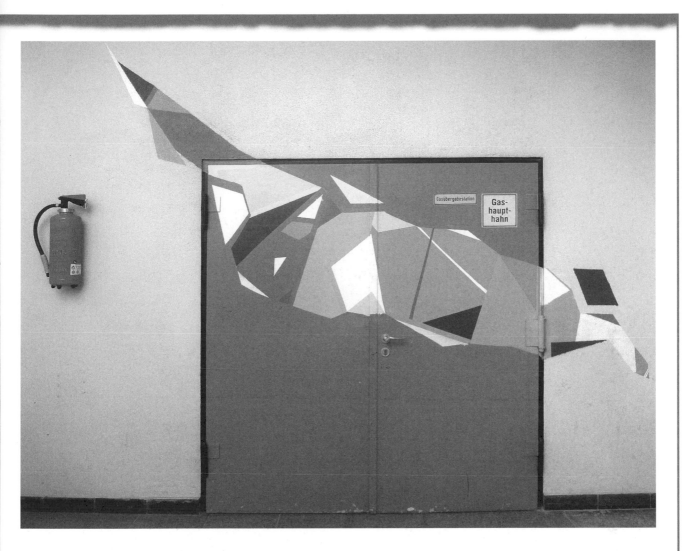

The next step Is to fill in the larger areas. When the paint on this first layer is dry, use more tape to give neighbouring areas equally clean-cut edges. It should be possible to create 3D effects at the corners, or at any of the places where shapes meet. Students can experiment with the different types of contrast mentioned on page 88 to give shapes depth or a 3D block appearance.

Other areas can be filled with fades to give an abstract look. Note that when adding fades it is advisable to cover up the surrounding area to guard against overspray.

Finished graffiti of a high standard is a great way of livening up dull classrooms.

[Exercise] Complex design in small groups

This is an advanced exercise for groups of 3–5 students. The task asks students to – individually – sketch a geometric shape with graffiti-style backgrounds. The group then synthesizes these draft designs into a single design. Students should be encouraged to include realistic objects or structures, which, if possible, should break out of the graphic shape. This will help make their designs eye-catching.

The purpose of the activity is to help students with designing and arranging interesting patterns around a main subject. An extension exercise could introduce a discussion focusing on which elements of the composition are most successful, and why.

Graffiti magazines and websites are good places for students to get inspiration on lettering and images.

Brains, spray cans, sunglasses, electric guitars, musical notes, halos and flags have all been added to make these pieces look unique.

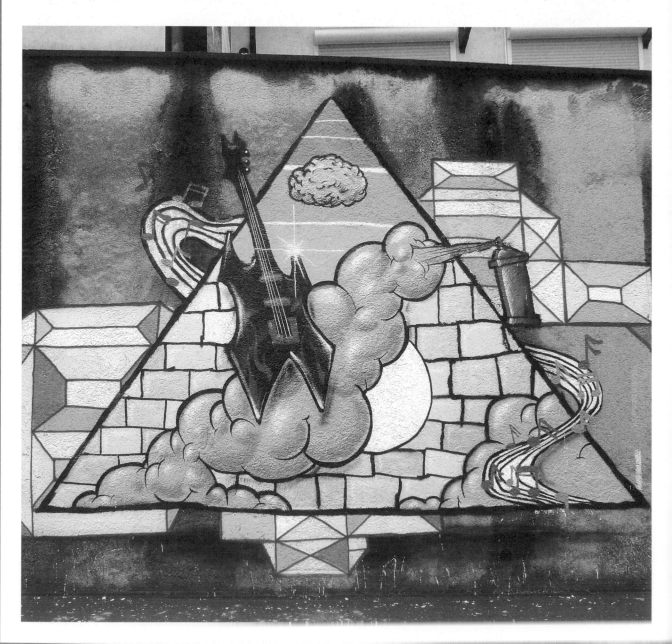

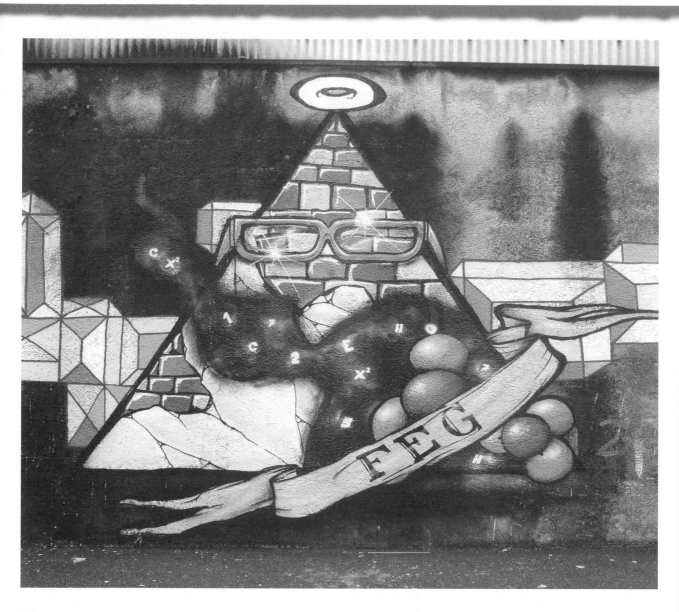

Design phase

[**1**] Everybody sketches their own concept for the piece.

[**2**] Ideas are compared within the group, and the best patterns and objects are picked out.

[**3**] Together the group decide on how to join the selected elements.

[**4**] Another sketch is produced, combining the chosen single elements and patterns. A suitable colour scheme is agreed on.

Practical phase

When transferring the final sketch to the wall, geometric shapes can be marked out with masking tape. Each student should sketch their contribution to the final design onto the wall.

After the sketch-up is done, the masking tape can be removed and the missing parts of overlapping objects added. The next step is to fill in areas with colour and outline them. Once this is done, final effects such as highlights, dusting and shadows can be added to complete the piece.

Solutions and sample alphabets

[Exercise] Tags 3

Solutions to exercise on page 34.

[Exercise] Throw-ups 2

Solutions to exercise on page 44.

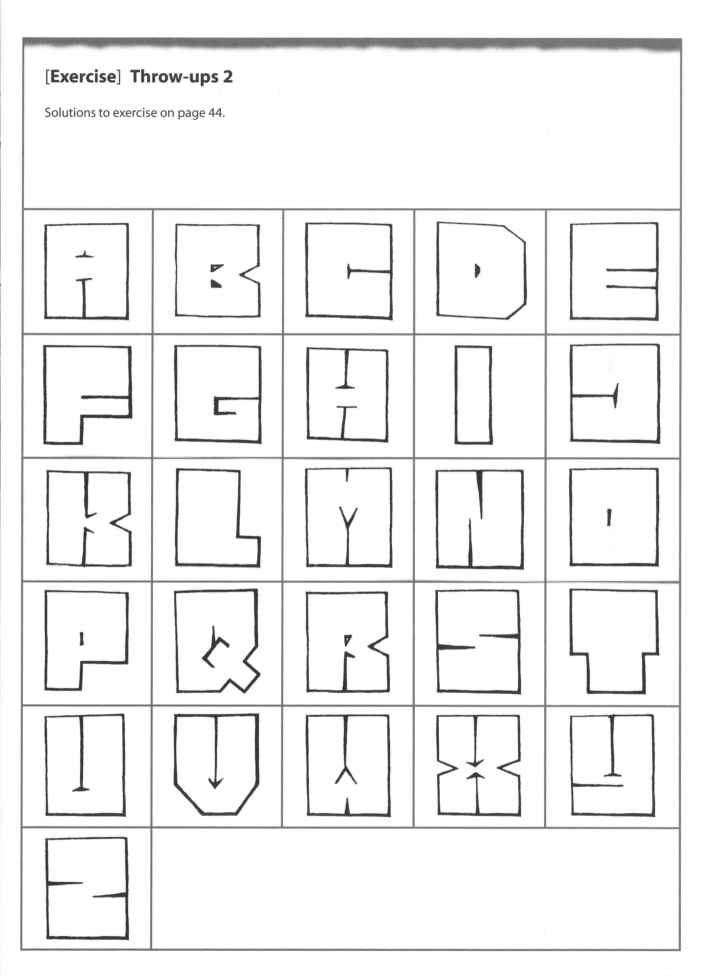

[Exercise] Key areas 2

Solutions to exercise on page 54.

A E G H

K M R S

W X Z

[Exercise] Fitting letters

Solutions to exercise on page 56.

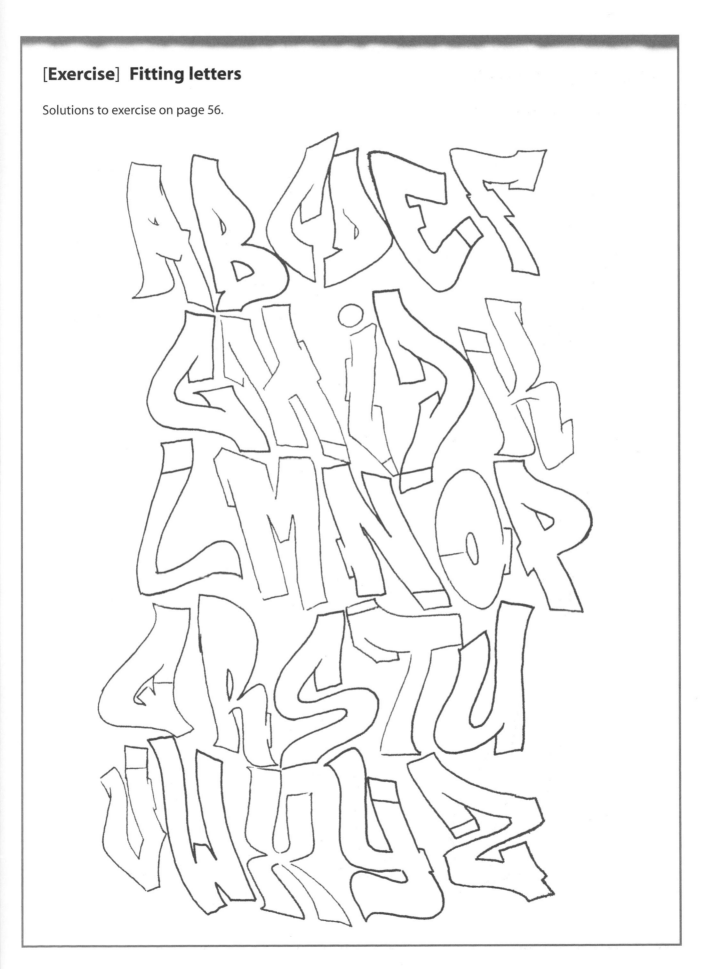

[**Exercise**] 3D blocks

Solutions to exercise on page 78.

[Exercise] Shadows

Solutions to exercise on page 79.

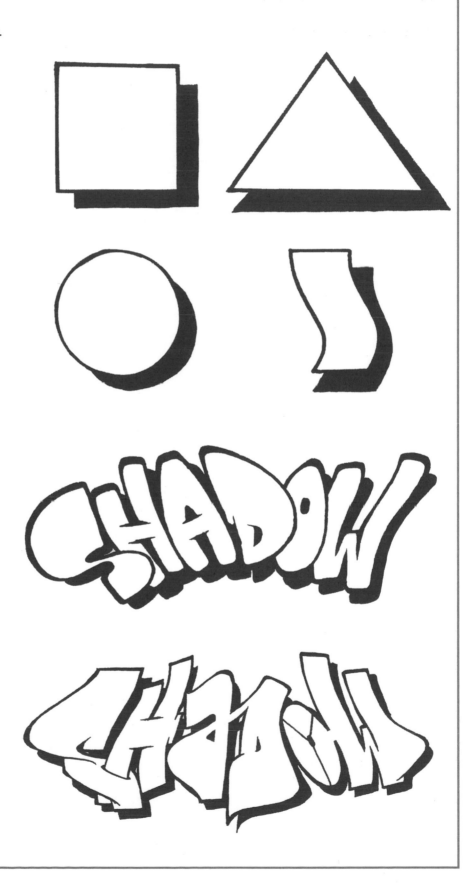

[Exercise] Cracks and drips

Solutions to exercise on page 80.

[Exercise] Style 1

Solutions to exercise on page 144.

[Exercise] Style 2

Solution to exercise on page 145.

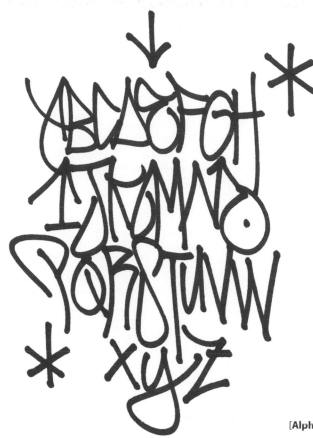

[**Alphabet style**] Tag alphabet by Alek3000

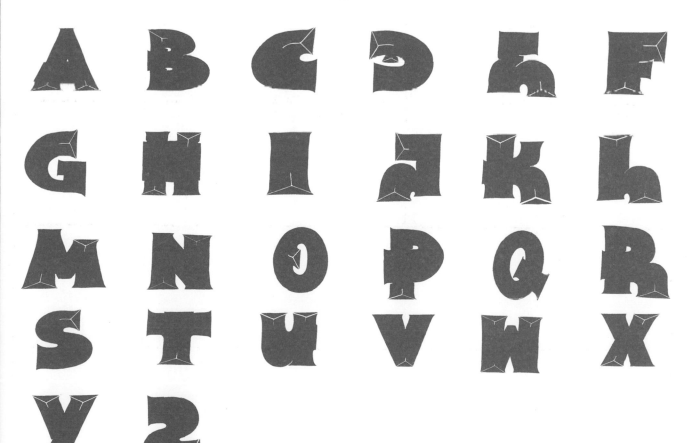

[**Alphabet style**] Throw-up/blockbuster
alphabet by Malör

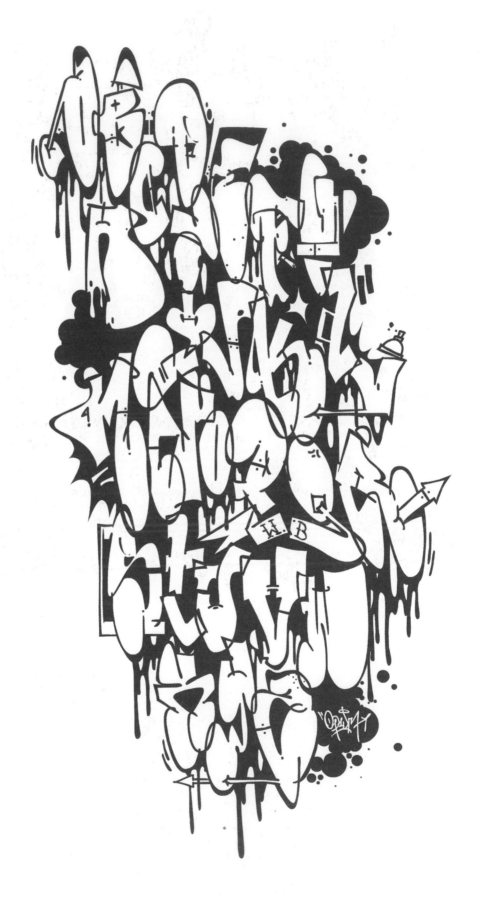

[Alphabet style] Throw-up/style alphabet
by Opium

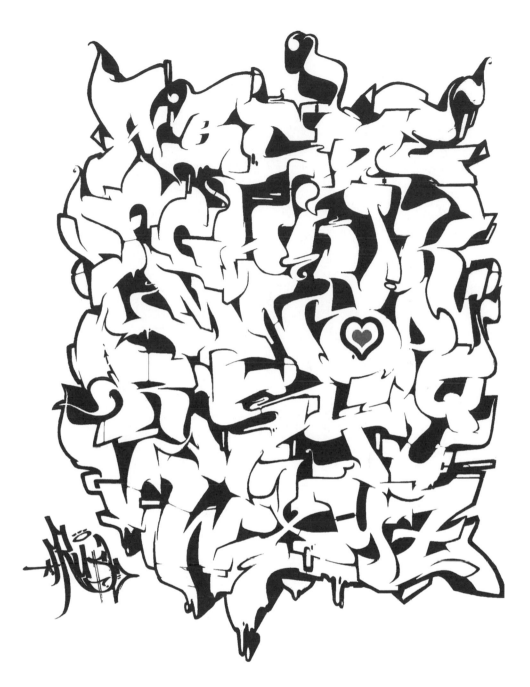

[**Alphabet style**] Two alphabets by Rusl. One with straight lines (left) and one with swings (above)

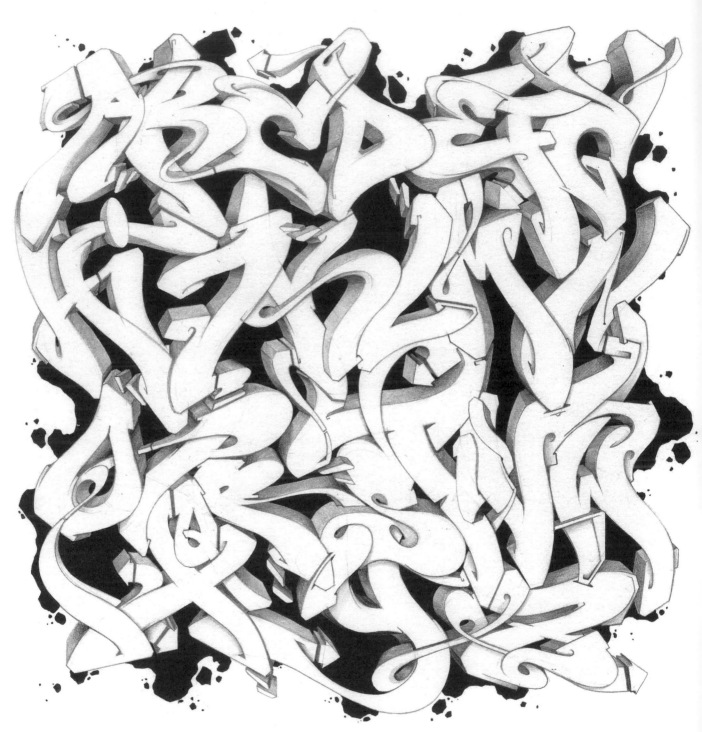

[**Alphabet style**] Style alphabet with
a 3D effect by Bash

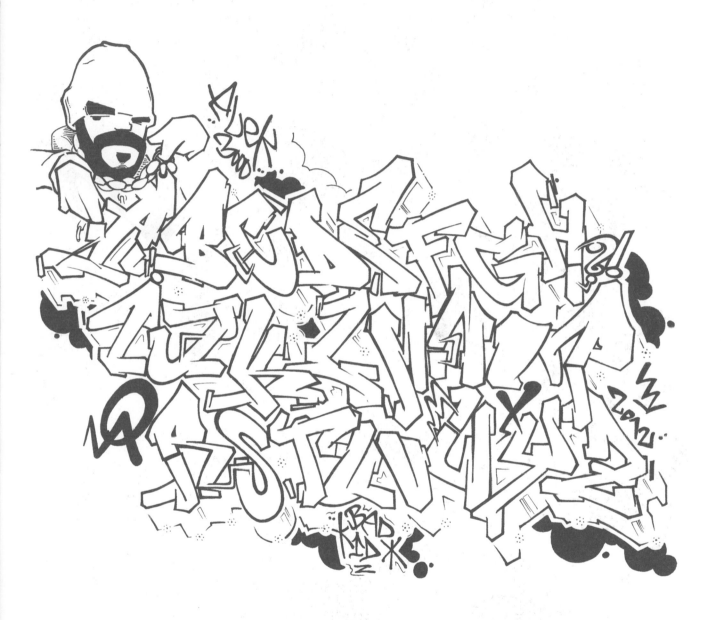

[**Alphabet style**] Style alphabet by Alek3000

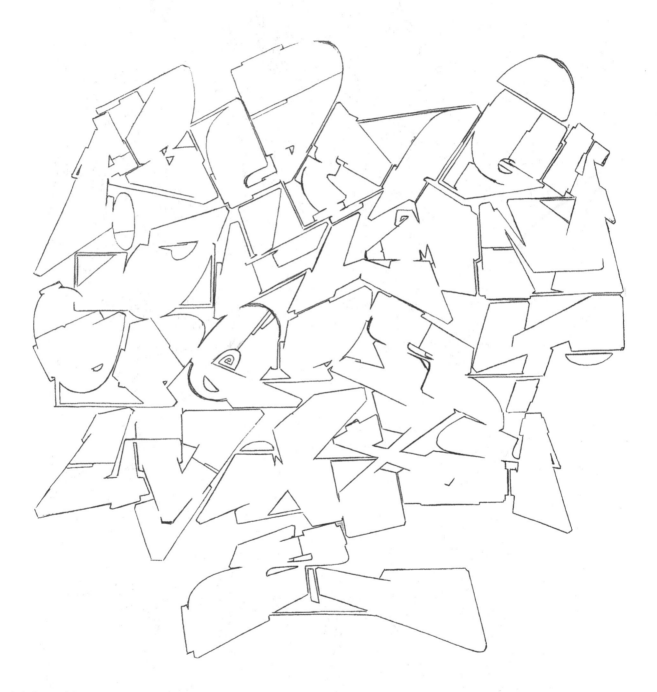

[**Alphabet style**] By Wert

[Alphabet style] Organic alphabet by Adonis

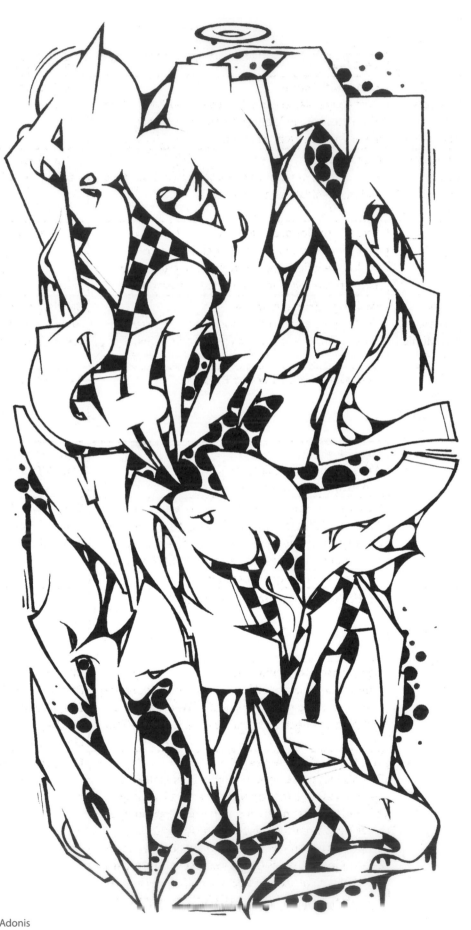

[**Alphabet style**] By Adonis

Timeline

When	Where	Key Style	Influential Artists
1970	United States (New York and Philadelphia)	**First graffiti styles** Most early styles are simple tags and outlined letters; often these are influenced by the typography of advertising and album covers.	Taki 183, Cornbread, Blade
1970–85	United States (New York and Philadelphia)	**Classic styles** Such oldschool styles as blockbusters, bubblestyles and semi-wildstyles are created.	Futura 2000, Skeme, Dondi, Zephyr, Seen, Cap, Iz the Wiz
1980–90	United States	**New wildstyles are invented** For example, writers in Los Angeles develop a wildstyle influenced by cholo writing (a Latino handwritten style) and using gothic elements.	Ces, T-kid, Cope2, Tats Cru, Saber
1983–85	Europe (Amsterdam, Paris, Munich, Berlin)	**Evolving European scene** Most writers adopt oldschool NYC styles; however, letters get more abstract and unconventional.	Bando, Jayone, The Chrome Angelz, Chintz, Amok, Shoe, Bates, Sento, Poet, Phos4
1985–90	Europe (Amsterdam and Munich)	**European writers develop 3D styles**	Delta, Loomit, Daim
early 90s	Scandinavia	**The ill style** Writers draw simple letters with extreme and extravagant proportions.	Nug, Ikaroz, Egs, Kaos, Cazter, Sabe, VIMOAS
1990–2000	Europe	**Eurostyle influences graffiti styles worldwide** Eurostyle deliberately ignores rules, deconstructing and reinterpreting traditional letter forms. New techniques and patterns, designs and backgrounds are added to the style inventory.	CMP, Dare, GT Crew, Phos4, Cantwo, Mason, Mode2, Atom, Toast, Razor, Swet
1995–2000	Eastern Bloc, South America and Asia	**Graffiti scenes develop further afield**	
2000–present day	Worldwide	**New generation Eurostyle** Writers combine and refine existing techniques and effects, creating new forms of 3D block, shadow and perspective effects. Fatcaps are used for dust effects.	MSK (Roid, Aroe, Gary, Rime, Revok, Ewok), Sofles, Dem 189, Dez, Jack, Jeroo, Smash 137, Lek, Dejoe, SatOne, Via Grafik, Dems, Gorey
2005–present day	Berlin, Paris	**The anti-style emerges** This distinct throw-up approach is popularized in heavily graffitied metropolises. The style is mostly painted with standard caps and deliberately ignores aesthetic proportions and clean technique. It can be seen as the anti-movement to the dominant and clean high-tech styles (such as Eurostyle). Anti-styles stand for a return to the basics of graffiti and in some ways resemble traditional NYC oldschool styles.	Mr Ix, Ehso, Honet, Horfe

Glossary

backjump a graffiti piece painted on a train that is stationary but in service

bite to steal the lettering or ideas of another writer

blackbook (or piecebook) a writer's collection of photos or sketches

block 3D effect

blockbuster style 3D-effect lettering that covers as much of the background as possible

bombing graffiti completed quickly, mainly tags and throw-ups

buff to paint over or obscure graffiti with a single colour

burner an outstanding graffiti piece

busted caught by the police

cap a spray can's plastic nozzle

character a figure or cartoon used to decorate a piece (often in a funny or meaningful way)

cross to deface a graffiti piece with a line or a tag

cut to overpaint lines with the background colour to make them sharper

end-to-end a train car sprayed with graffiti along its entire length

fatcap cap designed for painting thick lines

fill-in the colour(s) used to fill in letters

freestyle graffiti completed without a sketch

hall (of fame) piece legally sprayed graffiti

king the most highly regarded sprayer

linepiece graffiti piece next to a train line

oldschool 1. an experienced writer, who has been spraying for a long time; 2. classic style from the 1970s and early 80s

one-liner a tag or throw-up that is painted using one unbroken line

panel a discrete graffiti piece on a train

rack to steal

rollerpiece a graffiti piece with letters (or outlines) created with paint rollers

rooftop a graffiti piece painted while standing on the roof of a building

second outline (or keyline) outlining an entire piece

skinnycap cap designed for painting thin lines

softcap cap for dust effects and soft fadings

standardcap the industrial standard cap (which gives a fast, if fuzzy, line)

station graffiti piece inside or near a train station

streetpiece illegal piece in a street

tag a writer's stylized signature, often just a few letters long

throw-up quick letter outlines, often filled with hatching or a single colour

top-to-bottom a train car sprayed with graffiti for its entire height

toy a beginner on the graffiti scene (or a derogative term for an experienced writer)

wholecar a train car that has been completely covered in graffiti

wholetrain a train completely covered in graffiti

writer a graffiti sprayer

Further reading and internet links

Books

The Art of Getting Over, Stephen Powers (New York, 1999) Offers an illustrated general history of the beginning of modern graffiti

Blackbook Sessions (Stylefile vols 1–4), Markus Christl et al. (Aschaffenburg, 2003–2010) Graffiti sketchbooks compiled from the work of European writers

Freight Train Graffiti, Roger Gastman et al., with a foreword by Henry Chalfant (London and New York, 2006) Thoughts from over one hundred of the most influential and prolific freight train artists (many interviewed for the first time)

Graffiti and Street Art, Anna Wacławek (London and New York, 2011) A survey tracing the origins and evolutions of graffiti and street art

Graffiti World: Street Art from Five Continents, rev. ed., Nicholas Ganz, edited by Tristan Manco (London & New York, 2009) Over 2,000 pictures of artworks from more than 180 international artists

Overground (vols 1–2), Malcolm Jacobson et al. (Årsta, 2003–2006) Charts the work and inspiration of renowned Scandinavian graffiti artists

Street Fonts: Graffiti Alphabets from Around the World, Claudia Walde (London & New York, 2011) Anthology collecting graffiti alphabets from writers across the globe

Subway Art, rev. ed., Martha Cooper and Henry Chalfant (London & New York, 2009) Groundbreaking collection of legendary New York graffiti artists and styles

Online resources

www.artcrimes.org Collection of graffiti images, stories, links and useful resources

www.getnloose.com Frequently updated blog featuring photos, interviews, reviews and music

www.heavyartillerys.com Website featuring works from this British crew

www.legal-walls.net Addresses and short descriptions of legal walls around the world

www.spraybeast.com Blog with top pieces, interviews, reviews and an annual award

www.streetfiles.org International platform with over 700,000 photos of graffiti

Picture credits

All photos and illustrations © Chris Ganter unless otherwise stated

p. 13 *below* courtesy Orion/The Kobal Collection
[*Beat Street* (1984) directed by Stan Lathan]

p. 23 *above* courtesy Public Art Films
[*Style Wars* (1983) directed by Tony Silver and Henry Chalfant]

p. 23 *below* courtesy Wild Style/The Kobal Collection
[*Wild Style* (1983) directed by Charlie Ahearn]

p. 85 rat, superhero and female characters by Eazy

p. 86 *above* wolf character by Nychos

p. 86 *below* cowboy by Law One

p. 141 *above* © Peter Horree/Alamy

p. 141 *below* photo by Acid

p. 163 *above* tag alphabet by Alek3000

p. 163 *below* throw-up/blockbuster alphabet by Malör

p. 164 throw-up/style alphabet by Opium

p. 165 both alphabets by Rusl

p. 166 style alphabet by Bash

p. 167 style alphabet by Alek3000

p. 168 *below* style alphabet by Wert

p. 169 organic alphabet by Adonis

p. 170 organic alphabet by Adonis

Credit is also due to Inksulin, who helped with the tag alphabets, and to Ogre, who helped with the timeline.

Acknowledgments

I would like to thank all the artists who have contributed alphabets, as well as the Kyselak Project in Vienna (www.kyselak.at) and the Scheffel Archiv in Karlsruhe (www1.karlsruhe.de/Kultur/MLO) for providing material. Special thanks go to Anna Patzwahl, Adam Paynter and Tom Goulden for helping me to make this book a reality.

Index